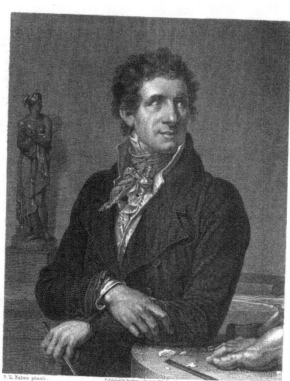

F. S. Fabre pinxit.

Published by Septimus Prowett 1826 March

W. H. Worthington Sculp.

Antonio Canova

THE

WORKS

OF

ANTONIO CANOVA,

IN

SCULPTURE AND MODELLING,

ENGRAVED IN OUTLINE

BY HENRY MOSES;

WITH

DESCRIPTIONS FROM THE ITALIAN

OF THE

COUNTESS ALBRIZZI,

AND

A BIOGRAPHICAL MEMOIR

BY

COUNT CICOGNARA.

VOL. I.

LONDON:

SEPTIMUS PROWETT, 23, OLD BOND STREET.

M.DCCC.XXIV.

THOMAS WRITT,
PRINTER, JOHNSON'S COURT.

BIOGRAPHICAL MEMOIR.

ANTONIO CANOVA was born in 1757, at Possagno, a village situated amidst the Asolani hills at the foot of the Venetian Alps. Pietro, his father, and also Pasino, his grandfather, were sculptors of repute at that time, as their numerous productions attest, consisting chiefly of monuments, altars, and similar works consecrated to religious purposes, in the churches of that district. By the death of his father, Antonio become an orphan in the third year of his age, and his mother Angela Zardo marrying shortly afterwards, and returning to her native town of Crespano, the infant was left to the care of his paternal aunt, Caterina Ceccato, by whom he was affectionately nurtured. His mother had by her second marriage, his step-brother the present Abbate Giovanni Battisti Sartori.

Deprived of his father, young Antonio was indebted for the rudiments of his art to his grandfather Pasino, who adopted the excellent method of teaching him early the familiar use of the implements of sculpture, employing him on the works on which he was himself engaged. By this useful discipline, his hand acquired mechanical skill, while his mind was growing to maturity, and he early possessed the advantage of being able to execute the rapid and instantaneous conceptions of his genius, with a corresponding facility.

B

It happened at this time that Giuseppe Bernardi, sur-
named Torretto, nephew and pupil of old Torretto, who
was one of the best of the Venetian sculptors, was staying
for some years at Pagnano, a short distance from the villa
of Asolo, where the patrician Giovanni Falier took so
much pleasure in embellishing his palace with the
works of contemporary artists. This nobleman ob-
serving the strong disposition of the youth for the arts,
placed him with Torretto, with the view of facilitating
his progress, and farther engaged that he should accom-
pany the artist to Venice, when the works on which
he was employed should be completed, and which
accordingly took place in about two years after.

By the death of Torretto, Canova was left without any
guidance or restraint, having received from his master
only the first instructions in his art, and before he had
acquired the maturity of strength necessary for venturing
on the new and arduous career to which he even then felt
himself incited by the most auspicious confidence. He
had enjoyed, however, ever since his arrival at Venice the
protection of his excellent patron Falier, and found an
immense source of knowledge and improvement in the
gallery of plaster casts of the Commendatore Farsetti,
comprising all the celebrated remains of antiquity, and
which, with a noble liberality, was devoted to the use
of young students, and the public curiosity. There
was also at that time an academy at Venice, calculated
to excite a spirit of emulation among the young artists,
but which was not enlightened by those juster prin-
ciples whose influence began then to be partially
visible, and was precursory of a new revival of the arts
in Europe.

Young Antonio was now placed with the sculptor Gio. Ferrari, Torretto's nephew, and worked with him on the statues that embellish the gardens of the Casa Tiepolo, at Carbonara : here he had young Gattinoni for his associate and rival, whose death, however, happened soon after, when he had excited high expectations of future eminence. Canova did not continue in this school for more than one year; for, becoming strongly convinced of the necessity of a wide deviation from the rules of art, which he saw practised, he boldly resolved to endeavour to explore those paths which, he thought, had been used by the ancients, and from which he beheld with surprise and regret the departure of his contemporaries. His proficiency even at that early age was considerable, as it is attested by the two baskets of fruit which he sculptured in marble, in his fourteenth year, and which are yet to be seen on the first landing place of the Farsetti palace, now the Hotel della Gran Brettagna, at Venice.

His first effort was a group of Orpheus and Eurydice in the natural size, taken at the moment when forgetting the cruel prohibition, he sees his mistress separated from him for ever; a subject which is, perhaps, more suitable to the canvass than to marble, from the smoke and flames in which the figures are usually involved. The statue of Eurydice was completed in his sixteenth year, while passing the summer at the villa of his patron, having previously studied the model at Venice : that of Orpheus was begun the following year, in a study which he then occupied on the ground-floor of the inner cloister of St. Stephano. This composition, in soft stone, was publicly exhibited in Venice, on the

occasion of the festival of the Ascension, and first
awakened the admiration and ambition of his coun-
trymen, who then began clearly to foresee the
meridian glories announced by so bright a dawn.
These two statues are now preserved in the Falier
palace at Asolo. In the following year he repeated
this subject in marble, in a rather smaller size, for the
senator M. Antonio Grimani. The destiny of this
group has been remarkable, the figures having been
separated from each other; and the fate of that of
Eurydice being even now unknown; the Orpheus was
sold by Grimani to Sig. Lorenzo Vanzetti of Vicenza,
and afterward resold by him for a considerable sum,
and sent to Vienna, having had some injuries, which
it had suffered, previously restored by the sculptor
Bosa. A still worse fortune befel the statues of Apollo
and Daphne, which he had sketched in soft stone, which
were destroyed by the brother of the late Luigi Verona
at Padua: but the most elaborate composition which
Canova executed previously to his departure from
Venice, was the group of Dedalus and Icarus, in which
he more signally evinced his daring abandonment of
conventional modes, and his entire devotion to the
guidance of nature. This group, which is now in the
Casa Barbarigo Pisani, was executed in a more conve-
nient study, which had been procured for him near to
the passage of St. Maurizio, where he also sculptured
the statue of Esculapius, and one of the Marquess
Poleni: the former being now in the villa Cromer at
Monselice, the latter in the Prato at Padua.

 The rapidity of his progress now prompted his illus-
trious patron to procure for him more adequate means,

and a loftier theatre for the exercise of his powers; which
he effected in concert with the Chevalier Girolamo Zulian,
who was at that time the Venetian embassador to the
Holy See, and his intimate friend; procuring for the
young artist the means of visiting Rome, and of pur-
suing his studies there with every necessary advantage.
Accordingly in December, 1780, Canova entered for
the first time that seat of the arts, little imagining that
he was destined to attain there to the highest rank and
to establish rules of art, by his example, which would
extend their influence to the remotest posterity. A
year had elapsed from the date of his arrival at Rome,
before a pension from the Venetian government was
obtained for his support: this was, however, finally de-
creed in the following December, consisting of an annual
allowance of 300 Venetian ducats, for three years, a
sum fully equal to the moderate wants of the artist,
and which, although it does not exceed the half of the
stipend now granted in similar cases, was at that time
thought amply sufficient.

On his first arrival at Rome, Canova had expe-
rienced the kindest reception from the Venetian
embassador, and had free access to his splendid
mansion. This enlightened and accomplished noble-
man soon becoming impressed with a high sense of the
merit and powers of the young sculptor, procured from
Venice a cast in plaster of the group of Dedalus and
Icarus, which he had executed in that city, for the
purpose of exhibiting it to the artists and connoisseurs
at Rome. The house of the embassador was, indeed,
a kind of athenæum, and frequented by all those most
distinguished by talents and genius in that city. On

the occasion of the first production of this group, he was surrounded by Cades, Volpato, Battoni, Gavin Hamilton, Puccini, and many other distinguished artists and critics, who contemplated the work with silent astonishment, not daring to censure what, although at variance with the style then followed, commanded their admiration, and revealed the brightest prospects. The embarrassment of the youth at this juncture was extreme, and he frequently spoke of it afterward, as of one of the most anxious moments of his life; from this state he was, however, soon relieved, by the friendly and paternal address of Gavin Hamilton exciting him to unite with so exact and beautiful an imitation of nature, the fine taste and beau ideal of the ancients, of which Rome contained so many models, predicting at the same time, that by such a course he would greatly pass the limits which had been reached by the moderns; but the censure which he overheard from one who stood behind him, was more agreeable to the young artist than any direct eulogium: this Aristarchus observed, that from the effect produced on the observer, by the naked forms so carefully finished in this group, they must have been taken from the life, when in reality they were wholly the result of his severe study of the human form, entirely unassisted by mechanical means: this greatly encouraged the young artist, and convinced him that he had already raised himself above the mediocrity of his contemporaries.

From the moment of his arrival at Rome he had commenced a severe and profound study of the great models of ancient art, without however neglecting the

fruits of his previous close observance of nature, the expression of which he always proposed to himself to make a distinguishing quality in his works. He had a profound contempt for all conventional modes in the arts, and was led even in that early age, by a correct taste, rather than by instruction, to prefer, among the monuments of ancient art, those which were of the age of Phidias, in which the lofty conceptions of the artist are most closely united with truth of expression; a decision which has since been fully confirmed by the exhibition made to Europe by the British Museum, of the first certain monuments of the arts of that era.

It may be proper to take here a slight survey of the various circumstances which had promoted the improvement in the arts previously to the arrival of Canova at Rome, for the influence of the genius of one man could not have been wholly adequate to the reconducting of art into its true but forsaken paths, unless the approach to them had been cleared by the sound judgment of some of his predecessors, and without the aid of other favouring circumstances: indeed, the influence of established practice and professional jealousy created no trifling obstacles to the progress of Canova ; These, however, his modest and unpresuming conduct aided greatly to remove, while an air of triumph and superiority would, by wounding the feelings of his rivals, have created additional opposition. Already, however, many causes had existed tending to an improvement in the arts ; among them may be enumerated the encouragement to right studies given by the Marquess Tanucci, at Naples; the protection afforded to literature and the arts at the courts of Charles III.,

Leopold, Benedict XIV., Clement XIV., Pius VI., and by Cardinal Silvio Valenti, the Colbert of the Holy See; by the Albani, the Zelada, and the Borgia; the studies of Mazzocchi, Bajardi, Galliani, of the two Venuti, of Maffei, Gesnero, Gori, Passeri, Paoli, and Amaduzzi; the good taste diffused by Cochin, Bellicard, Burlington, Mariette, and Sir William Hamilton; the Herculaneum discoveries; the Travels of Saint Non, Norden, Pocock, Wheeler, Spon, Revet, and Stuart; the exact admeasurement of ancient architecture by Des Godetz; the masterly works of the Piranesi on the Antiquities of Rome; the illustration and rendering public of galleries and museums, by means of engraved copies; the opening of baths; the study of the galleries of the Vatican; the excavation of old edifices; the collection and illustration of old inscriptions by Morcelli Marini, Zoega, Fea and Akerblad; the great works of Visconti and Winkleman; the enlightened taste of the Earl of Bristol, and of the Ambassador D'Azara, for these studies; the genius and profound erudition of Hancarville; the valuable collections of Hamilton, Jenkins, and Agincourt; the perfection of the intaglios of Pickler; the fine and bold designs of Flaxman; the attractions given to these studies by the accomplished Algarotti; the triumph over prejudices of the formidable Milizia; the labours of Temanza and Lanzi—these all supplied immense sources of aid to the young Phidias, and seemed to him to point out that moment as the favourable one for the giving of a different direction to sculpture from that which was pursued by living masters.

It is remarkable that both sculpture and architecture

should, at this time, owe their revival to the genius of Venetians; for while Canova was sculpturing his first great works at Rome, Ottone Calderari was reviving the Grecian taste in Vicenza, and Querenghi at St. Petersburgh, was fulfilling, in a masterly style, the magnificent views of that imperial court, by the erection of sumptuous and elegant edifices of every description. It must be allowed, however, that no ordinary degree of genius and courage was required to break loose from the false and vicious rules of art which then prevailed, particularly in sculpture, as not one of his contemporaries had, with all the incitements which have been enumerated, yet advanced a single step in that direction. Indeed, the works which Canova first saw in Rome, the productions of Agostino Penna, Pacili, Bracci, Sibilla, Pacetti, and Angilini, are already sunken into total neglect; neither can we discover in them the source of the slightest excitement to the improved style which the Venetian pupil afterward required.

The Chevalier Zulian now saw the importance of giving effective assistance to the developing powers of Canova; he, therefore, placed at his command a fine block of marble, to be devoted to a subject of his own choice, and to shew the profit derived from his residence and studies at Rome. This was the first marble sculptured by Canova, on those true principles by which he had proposed to himself to be guided in his works, a composition by which a new path was opened to all the productions of the imitative arts. The subject which he chose was Theseus, conqueror of the Minotaur, and the work was conducted throughout in

c

the palace of the Venetian Embassador. It was a
highly interesting moment, when his excellent patron
produced a cast of the head only of the Theseus to a
party of the first artists and critics assembled in his
house, without informing them whence it had been ob-
tained; all concurred, however varying in other points,
in pronouncing it to be of Grecian workmanship;
many thought they had seen the marble from which
it had been taken, not being able however to recol-
lect exactly where it was; but when the Embassador
conducted them before the original and entire group,
their surprise was indeed extreme, and they were forced
to exclaim, that by this work art had commenced a
new career; on this occasion it may be said that
Theseus was the conqueror, not only of the Minotaur,
but of Envy also, forcing from rival artists the first
homage of their admiration of Canova, who, at so
early an age, had raised art to a higher degree of per-
fection than had been attained by any sculptor since
its revival in Italy.

Before the expiration of the period for which his
pension had been granted by the Venetian senate,
the judgment and friendship of Gio. Volpato pro-
cured for him the commission to execute a monument
for the celebrated Ganganelli; this flattering offer
he would not however accept without the permission
of the Venetian Government. This being obtained,
by which he was left entirely at liberty in the
choice of the place of his abode and in the exer-
cise of his talents, he gave up his study in Venice,
which was finally closed in 1783, and returning to
Rome, applied himself wholly to this great work,

which proved the means of raising his fame to the very
highest rank. Previously to this undertaking, he had
sculptured at Rome only his Theseus abovementioned,
and a small statue of Apollo, in the act of crowning
himself, which he presented to the Senator Abondio
Rezzonico, one of his patrons, who died in 1782.
That severest of critics in the fine arts, Francesco
Milizia, a man of profound judgment and inde-
pendent mind, but violent and bitter in the expression
of his critical opinions, was struck with astonishment
at the excellency of the execution of the monument of
Ganganelli, and openly declared the highest admira-
tion of it in his letters—it also received the high enco-
miums of all possessing any knowledge and taste in
such subjects. To Volpato posterity are much in-
debted, who, with judicious confidence in the talents
of the young sculptor, procured the confiding of this
work to him, and thus afforded an opportunity of mak-
ing known his extraordinary powers to the world; the
greatest capabilities being often unproductive, from the
want of such favoring circumstances.

At the same time that this great work was in progress,
he produced a youthful Psyche, and also modelled many
other works, particularly those beautiful compo-
sitions in bas relief, which first opened the eyes of
modern sculptors. These, which he used to model as
a relief from more arduous studies, began to appear
about the year 1790 ; and before any artist had ven-
tured on any thing in this style : they were all left in
the clay models, except that of Socrates parting with
his family, which was worked in marble with great
care and accuracy, and is now in the possession of the
Chevalier Guiseppe Comello at Venice. Canova rarely

employed his chisel on portraits, or bas relief, leav-
ing, in them, a field open for the exertions of minor
artists, and dedicating himself with surprising ardour
to the greater objects of collosal statues, monuments,
and groups.

The commencement of one composition was not
delayed until the completion of another, but while
his chisel was still employed on the tomb of Ganga-
nelli, he was forming the clay model of that of Pope
Rezzonico, which was placed in the church of St.
Peter in 1792; during the few succeeding years he
executed several statues and groups of Cupid and
Psyche variously represented; the group of Venus and
Adonis; the monument of Emo, now in the arsenal at
Venice; the first statue of Hebe, and the first of the
Penitent Magdalen. All these works were completed
before the expiration of the 18th century, so that in
the course of twenty years he had produced a greater
number of works than many laborious artists have in
the whole of a long existence: and it should be re-
membered that the practice which he himself subse-
quently introduced for lessening the labour of the
sculpture, by employing inferior workmen to reduce
the block to the last stratum of the superficies, was not
then in use. This adoption of mechanical aid he ef-
fected by forming his models of the exact size in which
they were to be worked in marble, and with the utmost
accuracy; he always, however, applied himself the last
hand to his works, giving to his marbles a softness
and delicacy of contour, and a minute accuracy of ex-
pression, for which we should look in vain in the works
of others of that time. Indeed, the great superiority of
Canova is more particularly seen in these last fine

touches of art, to which no one can perhaps equally attain, who has not early acquired a familiar use of the chisel, but trust their fame to the hands of subordinate artists; the last minute and finishing touches are those which require the highest powers of the artist, and are the means of producing his noblest effects; and in this respect the studious care of Canova is observable even in his latest works; but it is deeply to be regretted that the abuse of his physical powers in the early part of his life, when employed on his first great works, and the want of those pecuniary resources which he could afterwards command, greatly weakened his constitution; and he often declared that he was no longer able to sustain the enormous fatigues which the lions in the monument of Clement XIII., and certain drapery in that of Ganganelli had cost him ; the use of the trapano, which is attended with a pressure on the breast, had already produced a depression on that part which was perhaps the origin of that complaint under which he finally sunk.

In 1799, the Prince Rezzonico having occasion to undertake a journey into Germany, was pleased to take Canova with him, with the view of affording him some relief and repose from the great abuse of his health and strength : he accordingly accompanied the Prince to Vienna and afterwards to Berlin. This journey was highly beneficial to Canova, by diverting him in some degree from his habits of too close application; and perhaps he was indebted to it for the many years which he afterward lived and devoted to his art.

It was during the interval from 1792 to 1799, that Canova found an agreeable relief in the occasional use

of the pencil, executing in all twenty-two pictures of various dimensions: after which he never resumed it until August 1821, when he retouched with great boldness the large painting which he had executed for the church of Possagno in 1797, of the height of twenty-eighth palms; the subject, the appearance of the Eternal Father to the three Marys, and the disciples lamenting over the body of Christ. It is not true, as has been sometimes stated, that he thought very highly of his pictures, and that they had withdrawn his attention from more important subjects. This is sufficiently refuted by the short period of his exercising the art, the extreme facility of their style, the unwillingness he had that they should pass into other hands, although very flatteringly sought after, and the modesty with which he shewed them rather as the fruits of his leisure hours than of his serious study. This recreation, in which he found so agreeable a relief, arose from his return to those habits of living to which he had been accustomed from his early youth at Venice; having contracted an intimate friendship with Mingardi, one of the best painters of that day, by which means he naturally became familiarized with the pallet: but the style which he saw practised at Rome was very different from that of the Venetian colourists who, still influenced by the true masters of the pencil, did not hold in much esteem the pictures of Mengs, Battoni, and Maron; and it was no little gratification to him when one of his heads, coloured from the mere recollection of the manner of Giorgione, was taken by the connoisseurs for the work of an old Venetian master.

The personal habits of Canova were throughout

his life regular and moderate; he rose early and immediately applied himself to his designing or modelling, and afterward to working in marble; he was always disposed to live abstemiously, as well from motives of health as of reflection, as his intense application had made him easily susceptible of severe stomach pains; and in his twenty-seventh year he was attacked by a violent and complicated disorder, which ever after threatened him from time to time with a return, requiring of him great caution, and confirming him in his natural disposition for a sober and regular mode of living. It was his daily custom to restore his powers by a short repose after eating; and the friends who dined with him always took care to introduce light and diverting topics of conversation, and to avoid subjects of the arts, or of a nature to highly excite his imagination or feelings; a slight emotion having the effect of disturbing his usual repose. He seldom went from home, but passed his evenings in receiving his friends, with an extreme gentleness and urbanity of manners, but without the slightest approach to meanness or affectation.

It was his constant rule not to have pupils, at least in the strict sense of the term, and was used to assign as a reason for it, that if a youth of good capabilities were to study under him, the merit of his works would be attributed to the master, who would thus derive from it the benefit due to the unrequited pupil: but it was his invariable custom, whenever a young artist evinced more than ordinary power, or when any one of his workmen raised himself above mediocrity, to give him every encouragement, to procure commissions, for

him, and even to set him to work on his own account;
as in the instance of his causing to be sculptured at his
own expense, so large a portion of the statues which
adorned the Pantheon, but which have since their ex-
pulsion thence, been received into the various galleries
of the Capitoline museum. At any moment when re-
quired he would leave his own work to go to the study
of any artist who wanted his counsel or opinion, which
he gave with such cordiality, as never to wound their
professional pride, but, on the contrary, as always to
afford them aid and encouragement. To those who
express surprise, that not a single pupil of Canova can
be absolutely cited, it may be answered that, if they
will compare the state of his art at the era of his
earliest productions, with that of the present day, it
will appear most convincingly that the effect of the
examples which he has afforded to all Europe in his
own works, has been infinitely greater than what could
have been derived from a few precepts inculcated in
his private study.

He was very solicitous to instruct and adorn his
mind in every respect that could tend to the per-
fect education of an artist; he read himself, but
more often caused to be read to him, while at work,
the classical Grecian, Roman, and Italian writers,
particularly Polybius and Tacitus, whom he considered
most luminous and characteristical of the times which
they so masterly describe. His own style in writing
was always simple and ingenuous, although his letters
serve to shew the progressive correctness of his lan-
guage, so that the latter part of them without losing
their original force and freedom, and uncorrupted,

on the other hand, by the obscure affectation of modern
style, are more elegantly written than those of an
earlier date. He never wrote with a view of publish-
ing on the subject of his art, although it appears from
one of his letters that he had thoughts of doing it,
limitedly however and with much reserve; in a letter
to a friend dated 1812, he says, " you will be surprised
when I tell you that I have never written a single line
on the subject of my art : I have, however, always had
an intention, but have not yet found the moment for
carrying it into effect; perhaps at some future time I
may. I have determined, however, to give observations
on my own works, extending them, perhaps, to the
general subject of sculpture and its few elements ; but
not to make a work of it, which I could never be so
silly as to think of, but shall confine myself to the mere
exposition of the principles on which I have pursued
my labours, and nothing more." When circumstances
necessarily required it, he committed to paper some
valuable remarks, not however in the language of
dictation, although his authority was always willingly
submitted to. His clear, measured, and precise opinions
were, however, sometimes secretly noted by his friends ;
some of these will be made public by his memorialist,
who even while he was living, had thoughts of publishing
them in the disguised character of an old manuscript
lately discovered in the archives of the academy of St.
Luca ; for in this form only would he consent to have
his opinions, so ingeniously obtained, communicated
to the world.

His susceptibility and active fancy gave great
quickness and energy to his invention, prompting

D

his imagination spontaneously, and without effort, to
reach the great and excellent in his designs. He
usually threw his first thoughts on paper in a few
slight outlines, which he often varied and retouched,
and then sketched in clay or wax, in small dimensions:
with this he studied the composition of his subject,
which was afterward transferred to the full sized
model, and perfected with all the resources of his
genius and art. His tranquillity was never in the
slightest degree disturbed by jealousy of the success
of others, but on the contrary he always spoke of his
rivals and of artists of merit with the utmost candour
and good will. It was never his wish to be adopted
as a model, or to have direct imitators, observing, that
the great masters, by whom he had been guided, were
equally accessible to all, being no others than nature
and antiquity. He was, however, obliged to allow
that at the era of his first arrival at Rome, these two
sources of instruction had been neglected, and that he
had been the first to apply the means of improvement
which they afforded; but it was with the utmost
caution and modesty that he noticed this fact, to avoid
wounding the pride of others, who were not very
willing to do justice to his services, and attributed
much to themselves which was justly his due.

Criticism likewise never produced any irritation in
him; if false and violent, he wholly disregarded it; if
just and modest, he adopted the means of improvement
which it furnished, always, however, shewing great
deference for enlightened advice. When some of his
friends wished to reply to a certain Sig. Fernow,
who had published a pamphlet against him in German,

from which extracts had been made into the Ency-
clopædean Journal of Naples, he earnestly dissuaded
them from it, saying, that it was for him to answer
it, but only with his chisel and by an improvement
in his works; but he would listen with attention to
observations on his works, even by the most unin-
structed, from which, as Virgil could extract thoughts
from the verses of Ennius, he sometimes obtained
some useful suggestions, by which he has in some
cases been led to retouch his work; as in the in-
stance of his Perseus, and the group of Venus and
Adonis, which, in its way from Naples to Geneva, was
delayed for some time in the study of the artist, and
received some very valuable improvements twenty-
seven years after its completion. Undisturbed by
censure, he was on the other hand little elated by praise,
however high or exaggerated. The calmness and
modesty of his character, which few have ever possessed
in an equal degree, rendering him equally unmoved by
eulogy and censure. He has been frequently seen to
smile, when his panegyrists, chiefly with the object of
displaying themselves, have put their ingenuity to the
torture to discover remote allusions, or excessive
subtlety and refinement in his designs, and was used
to say, that truly he had never thought of any such
thing; but had only endeavoured to express in the
most simple and natural manner, those plain and
natural thoughts which had arisen in his mind, on the
contemplation of his subject.

More than once during his life, he experienced the
passion of love, in a degree corresponding to the
susceptibility and ardour of his nature, and has been

heard to say, that he was subject to its influence at a
very early age. On two occasions he was very near to
entering into the marriage state, but was, perhaps,
deterred by the apprehension of its diverting him from
his devotion to his art, which was always his master
and engrossing passion : his heart was, however, never
entangled by low attachments, but was the seat only
of the noblest and most elevated sentiments. Friend-
ship was held by him in peculiar veneration ; and to
the last hour, his soul was youthful in feelings, and
susceptible of the deepest and tenderest affections.

It was the good fortune of Canova to escape unhurt
the effects of the political events which then agitated
Europe, and to be able to devote himself, undis-
turbedly, to his art. Pallas seems to have guarded
him like Ulysses, by spreading around him a divine
atmosphere, which shielded off the disasters, priva-
tions, and misfortunes of that era. Ambition, and the
desire of military glory, characterised the great men
of that period, and particularly the great conqueror ;
calling for monuments to record their actions to
posterity, which object Canova was deemed most able
to fulfil : thus he was summoned to Paris in 1802, to
model the portrait of Napoleon, from which he first
executed a colossal statue in marble, and then in
bronze ; the first by the sport of inconstant fortune,
now being on the banks of the Thames ; the latter in
the academy at Milan, until a proper site be found for
this noble work of art. Highly interesting matter
will be supplied to the future historian of Canova, by
the conversations which Buonaparte, who so much
valued the frankness and simplicity of men of genius,

held with him on this occasion, in which plain and un-
disguised truths, such as are rarely heard in rooms of
state, were fearlessly uttered by the ingenuous artist.
The vigilance of his brother, who always accompanied
him in his journeys, was highly serviceable, in col-
lecting and noting at the time the interesting
dialogues which took place on this occasion; and also
when Canova was again called to Paris in 1810, to
model a portrait of the Empress Maria Louisa, whom
he represented in a sitting statue, with the attributes of
the Goddess Concordia, now in the palace at Parma.

In the interval of these journeys to France, he made
a second visit to Vienna, for the purpose of placing the
sepulchre of the Archduchess Christina in the church
of the Augustines in that city. This composition
added greatly to his reputation there, and excited so
strong a desire in the imperial court to possess his
works, that he was induced to send his magnificent
group of Theseus destroying a Centaur to Vienna,
rather than to Milan, for which city it was originally
intended. The Emperor Francis caused a temple, in
the style of the purest Greek models, to be erected in
the imperial gardens for its reception, and nothing was
wanting to the completion of the design but the
presence of Canova, to direct the placing of the group,
when his death intervened.

The fascinating influence which the grace and
beauty of his female figures exercise on the senses,
and the emotion produced by their tender and vo-
luptuous expression, has caused him to be called,
by many, the Sculptor of Venus and the Graces;
but it will not surely be said by posterity, that the

statues of the three pontiffs, the colossal groups of
Hercules and Lichas, and of Theseus and the Centaur,
the Pugilists, Hector and Ajax, Washington, the
colossal statue of Napoleon, the group of the Piety, or
the Equestrian Monuments of Naples, were imagined
in the gardens of Cythera. On these posterity will
decide, whether or no Canova possessed that profound
acquaintance with nature and anatomy which is in-
dispensible, to the perfection of works of this
description. It certainly will be allowed that his sci-
ence is not applied to a pompous display of himself, as
it is one of the peculiar merits of this artist, that he is
always modestly concealed behind his works, aiming at
justness of expression rather than an ostentatious dis-
play of his science in exaggerated forms; his works
were therefore addressed to his posterity, to whose un-
biassed judgment and discernment he appealed for his
fame. It is also true, that he attained to a high degree of
excellence in his female figures, and if a rigorous cri-
ticism should, in some instances, impute to them a
somewhat studied attitude—an expression approach-
ing to affectation, or redundant and elaborate attire,
it may be observed, that these objections principally
apply to figures represented in dancing postures, or in
motions to which simplicity or dignity would be wholly
unsuitable. These sprightly designs, which he used to
call his recreations,* have been engraved with a dark
ground, similarly to the Herculaneum subjects, and
seem to combine all the most pleasing forms and atti-
tudes of the dance; in the plates they are called
Danzatrici Baccanti Muse, &c. and in them we may

* Ozii suoi.

frequently trace out the first ideas of some of his more finished works.

The opponents of Canova have also charged him with not having confined himself to the use of the chisel in his marbles, and with having had recourse to factitious means of giving to them an extreme softness and delicacy; which, if it had been the case, would only have been following, in modern times, the example of Nicias, who produced these effects by his washes on the marbles of Praxitiles; but Canova rarely used any other means than that of washing his marbles after they had received their polish with *acqua di rota;* their soft and delicate surface being produced solely by his consummate chisel, and the diligent use of the file; unlike other sculptors, who think they have no more to do with their work when they have finished the model, and left its execution to the hands of subordinate artists. The exquisite finish of the extremities which his statues so peculiarly possess, may be attributed to the same causes: these are now openly kept as models in the workshops of the most candid and enlightened artists, but still used secretly by others, as if it was derogatory to learn from him who first pointed out the true path of art to modern sculptors.

No artist was ever more exposed to the intoxicating effects of honours and distinctions, exceeding perhaps any instance of the kind in the history of the arts; but although decorated with the equestrian orders of many great sovereigns, decreed noble in several states, dignified by titles, enriched by pensions, honoured by important charges and functions, received with distinction at all courts, desired in all societies,

and associated with all the principal academies in Europe, he still preserved the simplicity and modesty of his character, and even in the usual acknowledgment of these honours which he was called on to make, he avoided studiously all unnecessary pomp and ostentatious display. His disposition was naturally highly benevolent ; all his pensions and gains were devoted to useful and charitable purposes, such as the foundation of the Roman academy of Archaiology ; in pensions for the support of young pupils in the arts ; to the procuring of books for the academy of St. Luca ; aiding the funds of the academy de' Lincei ; in annual premiums to young artists who distinguished themselves ; in the support of decayed artists and their orphan and destitute families ;—these beneficent acts were done with the utmost nobleness, delicacy, and secrecy ; and even some interference was often required to prevent him from embarrassing his finances by a too active generosity. Rome, in 1811, felt more particularly the worth of Canova when deprived of its sovereign, deserted by foreigners, empty and impoverished, it saw the votaries of Pallas and the Muses pining in their workshops, without the means of support, and even perishing for want ; history will recount the succours afforded by Canova on this occasion ; with what judicious and noble means he supplied the wants of the youths dependant on the arts ; employing also numerous artists in making drawings and highly finished engravings of his works, and establishing an extensive engraver's press, an example which was afterward followed, but with a different object, by many others.

One of the memorable circumstances in the life of

Canova is the last journey he made to Paris, when
bearing the special mission of the Holy See, he mingled
with the great personages there assembled, and re-
claimed the spoils which the triumphs of the Gallic eagle
had swept from the Campidoglio and the Vatican; the
zeal and anxious exertions are indiscribable which this
worthy son of Italy used to execute the charge of his
master, and to regain for his country her violated
treasures; the firmness with which he urged the claims
of Rome, and his unwearied efforts to unite in her favour
the various interests and opinions, will afford an interest-
ing subject to the future historian of this illustrious
man. His re-entrance into Rome was a real triumph;
again the Transfiguration heard hymns in honour of
the memory of Rafaello, and the Apollo and Laocoon
recalled to Rome, now weak and fallen, the memory of
those joyous days, when amidst the triumphal pomp
of a Titus, or an Emilius, the spoils of conquered na-
tions entered her walls.

It was in these circumstances that Canova, deeply
affected by the great events of the times, so little
to have been foreseen by human thought, conceived
the design of perpetuating the memory of the
happy return of the Pontiff to his church; and he
accordingly, that same year, produced the model of
a grand colossal figure of Religion, of the height
of thirty palms, which he proposed to execute in
marble at his own expence, and make an offering of
to the Christian world. By the completion of this
design, the present age would have possessed a wonder
of art and sublimity to which it has never yet seen any
thing equal; emanating too solely and spontaneously

E

from the mind of the artist, wholly uninstigated and
unaided by extraneous means : all Europe looked for-
ward to see it adding to the glory of the Vatican, or
adorning the magnificent space of the Pantheon. Already
the model was completed, the marble disposed, and the
chisel of the sculptor suspended, until the signal of autho-
rity should be given, by pointing out the place appointed
for its reception. It will be for history to explain the
causes of the frustration of this devout and magnanimous
design, and perhaps it may be found needful to draw a
veil over the motives to which it may be traced ; pos-
terity will with difficulty believe, that no place could
be found at Rome for the reception of the sacred image
of Religion.—It is, however, certain, that the model
remained for many years the object of public admira-
tion, a masterly engraving being made from it with
the following inscription :—(Pro felici reditu Pii VII.
Pontificis Maximi, Religionis formam sua impensa in
marmore exculpendam Antonius Canova libens fecit
et dedicavit,) and that, finally, it was worked in marble
a little above the natural size, by the order of Lord
Brownlow ; and the emblem of Catholicism was thus re-
jected from the Tiber, and found refuge on the banks
of the Thames.

This extraordinary circumstance did not, however,
depress the mind of Canova, who, actuated by the
deepest religious feelings, had already formed the
design of consecrating his fortune and the last
efforts of his genius to memorize a period in which
the inscrutable decrees of providence had been so re-
markably displayed : and that the statue which he had
consecrated to this pious purpose might not be pro-

faned by any less sacred use, he resolved on the raising
of a temple for its reception in his native place, to be
enriched with the productions of his chisel ; by which
also he would open a perpetual source of prosperity
for his native village in the concourse of workmen, the
visits of strangers, and the expenditure of his entire
fortune. The first stone of this sumptuous edifice was
accordingly laid in July, 1819, amidst an immense con-
course of people, with all the solemnities of Religion,
and the deep emotions of the assembly ; but he had
not foreseen that this design would require an infinitely
greater expenditure than that of the colossal statue ; to
supply which, it became necessary for him to renew his
labours, and to undertake fresh commissions: accord-
ingly, he set about new statues, groups, and monu-
ments, working incessantly, and with all the ardour of
his youthful application ; his mind always intent on the
great object of his pious wishes ; it is not, therefore,
improbable that this greatly encreased exertion, and the
mental excitation consequent on it, tended to accele-
rate the termination of his existence.

Even at this stage of the life of this great artist, the
connoisseur may find new advances towards excellence
in his works, which is obviously to be attributed to the
opportunity which his voyage to England afforded him
of contemplating, for the first time, the marbles of the
Parthenon in the British Museum. The lofty terms in
which he spoke of them on his return, the profit he
derived from them, and the devoted admiration which
he ever after entertained for them, are subjects of great
and various interests ; he himself acknowledged that a
visible improvement, and the highest efforts of his chisel

were to be found in the works which he executed
subsequently to his visit to London.

In the latter part of 1821, he took a journey to
Possagno to inspect the progress of the work there,
and made many important alterations in his first
designs, necessary in the adaptation of an edifice
evidently formed on the united recollections of the
Parthenon and the Pantheon, to the purposes of a
Christian church. On his return to Rome he mo-
delled the group of the Piety, one of the principal
works which remains to be executed in marble, to the
great regret of all capable of feeling the beautiful and
grand in art; the first conceptions of this group were
most felicitous, and the composition most rapid, suf-
fering neither pause or amendment in its progress,
although from the profound science it involves, the
artist, had evidently to overcome great difficulties in
the expression of his ideas; when completed, however,
it formed the wonder of all Rome, and of the strangers
then in that city. In the course of the winter, he mo-
delled a monument for the Marquiss Berio, of Naples;
also seven designs for the Metopes of the church at
Possagno; the subjects taken from sacred history; and
a colossal bust, the portrait of an intimate friend;
with the advance of spring, he completed, with a de-
lightful finish, the group of Mars and Venus for his
Britannic Majesty, and also completed the recumbent
statues of the Magdalen, and the Endymion, which he
had executed for two distinguished English Noblemen.
Besides these important objects, he proceeded, at every
leisure moment, with other works which he had on hand.
The Sleeping Nymph, Dirce Nurse of Bacchus, a repe-

tition of the Nymph awakened at the sound of a Lyre, a Danzatrice, and various busts and other minor works.

In the month of May, he went to Naples, to inspect the wax of his second colossal horse, preparatory to the fusion of the work, and returned to Rome, with a tendency to disorder in his stomach, which was always badly affected by that climate; having recovered himself in some degree, and completed the works above-mentioned, he left that city, for the last time, in September, for Possagno, hoping to derive benefit from the journey, and from his native air, and arrived at that village on the 17th of the same month; but, as was usual with him, by a too hurried journey, and while he was still unable to bear the heat of the weather, which was, in that year, unusually great throughout Italy; indeed, he was very ill on his arrival, but continued there until the 3rd October, without taking to his bed, expecting relief from his native air and the waters of Recoaro, from which he had, on former occasions, derived benefit; all was, however, unavailing. On the 4th he arrived at Venice, intending to stay there for two or three days, having written as follows in the last letter that was signed by his hand :—" My health goes on as usual, or is perhaps rather worse than it was ; for a few days I thought it getting better, but I was disappointed ; perhaps the journey to Rome may restore me ; I would fain embrace you once again." No sooner had he taken up his abode, as he was accustomed, under the friendly roof of the Casa Francesconi, which he preferred to the many splendid mansions which were emulously opened to him, than he took to his bed.

The stomach failing in the performance of its functions, encreased his uneasiness; nor could medical aid at all abate a constant hiccough which gave him the greatest distress; his pulse, however, remained unaltered, and his head unaffected to his last moments. The friends whom he saw around him endeavoured, but ineffectually, to conceal the alarm and distress by which they were agitated. He heard with perfect calmness the announcement of the necessity of arranging his worldly concerns, and confirmed the disposition which he had made of his affairs many years before at Rome, but now made his property chargeable with the expenditure required for the completion of the church at Possagno; appointing his step-brother sole executor and heir, but who, in reality, became rather the distributor of his wealth, than the heir to it. He also expressed great satisfaction at having completed all the works for which he had been paid in anticipation.

Continuing for several days to get gradually worse, he performed the last offices of religion, and resigned himself to die with the utmost constancy and serenity, uttering only short sentences to his attendants, and of a pious nature: to those who administered to him the last soothing remedies, he said with his usual kindness of manner, " Yet give it me, that so I may remain a little longer with you." Approaching nearer to his end, he said to those who moistened his dying lips, " Buono buonissimo ma—è inutile;*" his last words were, " Anima bella e pura :†" these he uttered several times just before he expired, and if his spirit was not wandering at that moment, it may be said, that he

* Good, very good—but, it is in vain.
† Pure and lovely spirit.

died without any mental aberration. He spoke no
more, but his visage became, and continued for some
time, highly radiant and expressive, as if his mind was
absorbed in some sublime conception; creating power-
ful and unusual emotions in all around him: thus he
must have looked when imagining that venerable
figure of the pontiff, who is represented in the attitude
of prayer in the Vatican. His death was wholly unat-
tended by the agonies which make a death-bed so
distressing; nor did even a single sigh or convulsion
announce his dying moment. This took place on the
morning of the 13th of October, having then nearly
completed the 65th year of his age.

On the opening of the body, it was found that his
death had been caused by a paralysis of the stomach,
promoted by the schirrous state of the pylorus, by
which the passage of food into the intestines was
impeded.

The loss of Canova occasioned the deepest affliction
throughout the city of Venice; the power which
regulates human destinies having conducted him to the
tomb in that country where he had first drawn breath.
The patriarch himself would perform the funereal rites,
and the academic body, who were desirous of supporting
his bier, conducted the coffin of their revered brother
and master to the church, and thence to the hall of the
academy, followed by so numerous a train, that that
vast apartment was insufficient to contain them. The
walls of the hall were hung with engraved copies of
the works of Canova, so numerous that they appeared
the labours of a whole race of artists, rather than of a
single mind and hand. The president of the academy,

an affectionate friend of the deceased, delivered the oration, exciting in the minds of the assembly the same deep emotions by which he was himself affected. The only torch which burnt beside the bier, stood on that ancient bronze, which had for so many centuries been used to receive the votes of the patricians, in the hall of the great council, and was deemed a suitable candelabra for the last offices paid to the latter glories of the Venetian state.

Immediately after the ceremony, the body was removed to Possagno, where an honourable tomb will be raised to his memory, in the new church now nearly completed. The funereal rites were performed on the 25th of October, and a discourse delivered by a distinguished prelate, to so large a concourse of the inhabitants of that district, that it was found necessary to address them under the open sky. Throughout Italy, the deepest affliction prevailed on this event; Rome, who lost by his death the restorer of her modern greatness, decreed to him the honour of a statue, proclaimed him perpetual president of her chief academy, and ordered for him a funeral in the church of the Holy Apostles, of such magnificence, that all the tributary arts were occupied for many months in the preparation of it. The pope contributing largely to the expense, and the whole of the magistracy, together with the representatives of the first powers in Europe paying respect to it by their presence: likewise Florence, Trevigi, Udine, and Lodi gave each her public demonstrations of grief on this occasion; but none with more zealous promptitude than the Venetian artists, the kind friends and fellow-

academicians of Canova. Immediately on his death, they voted to his memory the grandest and most distinguished monument that could be devised; and not to limit the honour of this design to Venice alone, or even to Italy, the subscription was thrown open to all Europe, to whom his fame might be deemed to belong; whereupon the powers then assembled at Verona, following the example of our august Emperor, severally evinced their desire of promoting this object by munificent contributions; as the more distant sovereigns also did, on the announcement of the project. So rapid and considerable was the subscription, that long before the ensuing spring, they were in condition to begin the work.

A monument to the memory of Tiziano had been designed by Canova, in the year 1792, which it was intended to raise in the church de' Frari, in Venice; but the design, which was to have been effected by subscription, failed by the death of the Chevalier Zulian, its chief promoter, in 1795. The model being thus left on hand, without any prospect of its being carried into execution, Canova adopted the same idea for the monument of the Archduchess Christina, reducing, however, the dimensions, and with considerable alterations in the groups. The opportunity of restoring to its original state and colossal proportions, this beautiful composition, far more suitable to a consummate artist than a pious princess, and, perhaps, even better adapted to a sculptor than to a painter; the absence of all rivalship, in the adoption of the design of him whom all considered as a master, and the means it afforded of employing at the same time

F

the numerous sculptors, who were anxious to pay homage to the memory of Canova, all concurred to justify the choice of this model formed by the hand of Canova himself.

The academy of Venice, who obtained the heart of Canova, are also now raising a small monument entirely at their own charge, in the hall of their meetings, consisting of an urn of porphyry to contain the precious relic, with ornaments, and an inscription appropriate to the subject and circumstances.

The letters of Canova will furnish to those, who shall collect memorials of him, much that is valuable and interesting: these will be found in the greatest number with the noblemen Guiseppe, Falier, and Lorenzo Giustiniani, the heirs of Antonio Selva the architect; those of the painter Guiseppe Bossi, of Milan; with Count Tiberio Roberti of Bassano, Count Cicognara, at Venice, and M. Quatremère de Quincy, at Paris.

Canova enjoyed the peculiar protection of the patrician Giovanni Falier, as has been already mentioned, of the Chevalier Girolamo Zulian, of the Prince Rezzonico, and of the Marchioness Gentili, one of the most accomplished women of Rome, at the time of his arrival there. The number of persons connected with him, by the ties of friendship, was also very considerable; but if the degree in which it was enjoyed were to be determined by particular demonstrations of regard, the Chevalier Bossi and Count Cicognara, whose busts, while living, he sculptured in colossal size, and with whom he maintained an uninterrupted correspondence, may, perhaps, claim

a distinction in this respect. The following may also
be mentioned as his attached friends; Gio. Antonio
Selva; the sculptor, Antonio D'Esté, the constant com-
panion of his study; the excellent Chev.^{r.} Gio. Gherardo
de Rossi; that able writer, and his warm admirer, Pietro
Giordani; and the secretary of the academy of St.
Luca, the Abbate Melchior Missirini, with whom he
was for many years united by a strict similarity of
tastes and pursuits; and the Chevalier Tambroni; but
Gavin Hamilton, the Scotch painter, was the first at
Rome who gained the youthful attachment of Canova,
and he was never satisfied with speaking in terms
of grateful remembrance of the kind encouragement
and counsel which this worthy man afforded him in the
difficulties of his early career. M. Quatremère de
Quincy, Lord Cawdor, and Sir William Hamilton,
also possessed his friendship in a peculiar degree, and
gave, on many occasions, unequivocal proofs of an equal
esteem; but the most intimate, cordial, and inseparable
of all his friends was his step-brother, the Abbate
Sartori Canova, who, from the year 1800, resided
entirely with him, and became the participator in his
most secret and individual concerns; and to whose sole
and sacred friendship he confided at his death the
execution of his most cherished designs: but it would not
be possible, without exceeding the limits prescribed to
this memoir, to mention the many distinguished and
enlightened persons who experienced from Canova the
most ready intimacy and kindness. To him who shall
undertake a more comprehensive and detailed account,
these anecdotes will furnish much that is interesting,
as well to his contemporaries, as to posterity.

The high esteem in which Canova, while living, was held throughout Europe, is one of the most honourable records of art, and of requited genius; for, not only was he an object of admiration to Italy, and his own countrymen, but had in France also for his admirers, all those persons most distinguished for taste and impartiality of judgment; the French having been unjustly charged with holding his talents in light estimation, as is evident from the flattering notice he received from their learned bodies, the study and imitation of his works, the high price at which they were sold there, and the public expression of regret at his decease: nor was their respect for him at all diminished by the zealous activity which he shewed in recovering from them the precious spoils of his country. In England he was held in equal, or even greater estimation, and received, during the short visit he paid to that country after his last journey to Paris, the most generous and distinguished notice and attention.

The questions most commonly and earnestly put are, if Canova has reached in sculpture the excellence of ancient Greece, in what points the comparison may be made, and by what means he surpassed the sculptors of the age of Julius and of Leo. Contemporary jealousy will not allow of his title to this elevation; but this opinion will not greatly surprise those who are intimately acquainted with living artists, while to an unbiassed posterity may be confided the rank that he will permanently hold in the arts.

The sculptors of the fifteenth century, when the arts were subsidiary to religion, which was the chief pro-

moter of their revival in Europe, reached a high degree
of excellency, so far as regards expression, and the sim-
plicity and devotional air proper to subjects of piety :
the works of that period are accordingly characterised
by a timid expression of religious sentiments and
emotions, and confined to a mere imitation of nature.
By degrees the ambition began to prevail of sur-
prising the beholder, and of displaying the artist at the
sacrifice of truth of effect. The successive sculptors of
the sixteenth century proceeded to operate with greater
boldness, and throwing off what they deemed the
servile yoke of the imitation of nature, but without sub-
stituting a beau ideal, founded on the antique, with the
view of attaining to greater originality, proceeded from
one license to another, until all rules were abandoned ;
while destitute of the force and science of Bonarroti,
they possessed no qualities to redeem the faults which
he, as a sculptor, had rendered the idols of his age. A
superiority over the masters of both these periods will
then be readily accorded to Canova, who, with nothing
of hardness or timidity, in his imitation of nature, or
of falseness and tendency to error in his beau ideal,
formed a style, by the happy and inseparable union of
these two kinds of imitation, which constitutes the
true path to perfection; and if Michael Angelo has
left a mighty name behind him, in works of the pencil,
and of architecture, it is not necessary that posterity
should overrate the paintings of Canova, or the edifice
he raised at Possagno, to preserve the balance between
them, while his superiority in sculpture, more than
supplies any deficiency in respect to the other two
branches of art.

The degree in which Canova approximated to the excellency of Grecian art, is shewn in his masterly manner of treating those bold and novel conceptions, for which neither antiquity or the age of Leo had afforded him any precedent, and in which he stood entirely alone and original. These possess a justness and propriety of style, a freedom from all extravagancy, while the character and attributes peculiar to each work are never confounded together. In all his various productions, we always can admire a scrupulous perfection, in the extremities, a charming sweetness of contour, and a peculiar grace, but without affectation, in the motion of the neck, giving a fine expression to the head, and graceful disposition of the shoulders : but his marbles are above all distinguished by the exquisite representation of the flesh and appearances of the skin ; without, however, degenerating into a minute and servile imitation: he seems to have proceeded by first impressing on his statues all the divinity of his beau ideal, and afterward to recal them, if it may be so expressed, to humanity, by scattering here and there those traces of reality, which his attentive observation of the natural supplied ; these masterly strokes raised his figures into life, all the softness and delicacy of which were added by his last fine touches.

Sensibility and quick perception will fully suffice, without critical knowledge of art, to feel all the fineness and justness of his expression. The fury of Hercules hurling Lichas into the sea; the noble and heroic air of Theseus, in the act of slaying the Centaur; the various characters of Hector and Ajax ;

the pious figure of Clement XIII.; the deep affliction in the family group, on the tomb of the Countess D'Haro; the lofty courage of Creugas; the fell expression of that of Damoxenus; the mild dignity of Washington; the deeply empassioned group of the Piety; without mentioning his subjects of beauty and grace, so expressive of voluptuous, but at the same time pure and innocent emotions; these alone will be sufficient to sustain the character of Canova, in any trial or comparisons that may be made. Although he may not have reached the excellency of the Grecian masters, particularly in those few instances in which some degree of imitation of their works is observable, yet it may be affirmed, that he affords the only example hitherto, of such an attempt being made with any degree of success. This is attested by his statues of Perseus, and of the mother of Napoleon, which remind us of the Apollo and the Agrippina, without suffering greatly by the comparison.

The two colossal statues of Hector and Ajax, which were in his study at the time of his decease, wanting only some slight alterations, and the last polish, are yet almost unknown to the world, but will contribute to the reputation of the sculptor, equally with the devotional figure of Clement XIII., the Blind Man in the Monument of the Archduchess Christina, the Magdalen, the Pugilists, Hebe, Polymnia, and the group of the Piety, works for which no known models are furnished by antiquity.

The contents of his study will shortly afford a highly interesting and instructive treat to the artist and the amateur. These consist of his studies from life, of

every variety of character, sex, and age; of experiments of every kind of drapery from life, and models; and his original thoughts on paper, and in clay and wax models of various dimensions.

In a more enlarged biography of Canova, it might have been expected to find his defects, as an artist, more precisely pointed out; defects which he himself ingenuously confessed; but from the narrow scale on which it has been here attempted to give a faithful sketch of the life of this illustrious man, it has not been thought requisite to dwell on faults, inconsiderable in themselves, and wholly lost, in a general view, in the splendour of his excellencies.

ANTONIO CAJOVA.

From a bust finely after done by Lord Ashmole

Engraved by T. Mote.

Published by Charles Knight & Co. London.

CONTENTS.

VOL. I.

STATUES AND GROUPS.

CONTENTS.

CONTENTS.

CONTENTS.

LETTER

FROM

THE COUNTESS ALBRIZZI

TO

THE M......

P...... C...... A......

YOUR earnest and repeated enquiries respecting our
celebrated sculptor Canova, and his works, notwith-
standing the excuses which I have so frequently made
of inability to reply adequately on such a subject, have
at last induced me, desiring to oblige you, to attempt
a description of some of the compositions of this great
master; without, however, at all observing the order
of time of their execution, but merely that in which
I happened to see them and admire their excellence.
I aspire then only to awaken, in some degree, in you,
and in those who may chance to read these descrip-
tions, the same emotions which these sublime produc-
tions of the greatest genius of our age in the fine
arts excited in myself: if you should think them not
unworthy of being read, and I should have your
approbation as a pledge for that of others, I shall, in
a second volume, extend my remarks to many other

productions of this great artist which are now finished,
and even to those, with which, by that time, the world
may be enriched; working as he does, with excessive
ardour, and with a rapidity which is astonishing, con-
sidering the nature of his art, and that his aim is
perfection.

I intend also to write the life of this great man,
although, his whole existence being devoted to his art,
his compositions make us perfectly acquainted with
him, and contain, if I may so express myself, his
history: but as the knowledge of every particular
connected with so great a genius is valuable, I shall
give some account of his origin, and of those bright
rays which attended the earliest efforts of his chisel,
and gave birth to the highest expectations. How,
although endowed by nature with powers for excelling
either in the career of Phidias or of Zeuxis, he devoted
himself, with just confidence in his genius, to the more
difficult art of sculpture; but not so entirely that the
sister art, though neglected, is without profound and
luminous traces of his efforts.

In the course of these remarks I have found it
difficult to avoid the frequent recurrence of the same
epithets; for language furnishes us with few terms to
express those infinitely varied forms of beauty which
a profound artist presents to us, drawn not only from
exhaustless nature, but also from his own happy

combinations of the beau ideal : how often are we not obliged to employ the same term to express the various degrees of delicacy, suavity, severity, or harshness ?— in order to mark with precision these minute shades of difference, language should have been taught, instead of being the imperfect invention of man, by the same power who created in his works such endless and pleasing variety.

Not possessing a scientific knowledge of the sublime art of sculpture, I have not attempted a critical analysis, or technical examination of these marbles ; but have aimed at no other object than that of merely describing the effects which they produced on myself, with the pleasing hope of exciting in others the same sensations of admiration and delight. I am, however, aware of the risk which I incur of displeasing the amateur, by passing over many things which, in a regular criticism, would require a minute and technical notice ; and, on the other hand, of offending those who, preferring my unstudied remarks, assisted as they are by the outlines which accompany them, would rather avoid the tediousness of elaborate disquisition. I flatter myself, however, that the manner which I have adopted will be approved by you, whose mind and feelings are so much in unison with my own, and by many others who may accord with me on this

subject; but in whatever light this may appear to you, accept my good wishes, and do not reproach yourself, that, through your instances, my time has perhaps been occupied to no purpose, and my vanity exposed to some danger: for, in respect to the former, can one's time be more agreeably occupied than in discoursing, in company with the great Canova, of the most illustrious and admirable personages that are to be found in history or fable? and for the latter, I flatter myself, that the general indulgence which is shewn towards our sex, whose literary efforts are usually treated with partial kindness rather than rigid criticism, will effectually shield my pride and reputation.

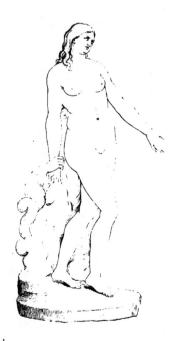

EURIDICE.

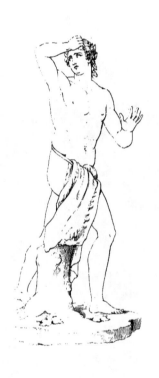

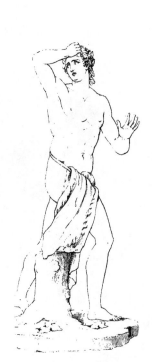

OSIRIS.

EURYDICE AND ORPHEUS.

(STATUES IN SOFT STONE.)

———

CANOVA, while a boy, and under his paternal roof at
Possagno, evinced his genius for the arts by sculptu-
ring baskets of fruit, the bust of a friend or relation,
or modelling a lion in miniature : but his manner of
doing these trifles, like the infant sports of Hercules,
gave promise of what was effected in the maturity of
his powers. While still a youth he read with great
delight the beautiful fictions of Grecian Mythology;
among which the pathetic story of Orpheus and
Eurydice powerfully awakened his sensibility, and
prompted him to attempt a representation of that
subject. He accordingly modelled and executed the
statue of Eurydice, in his sixteenth year, and that of
Orpheus about two years after, for the Venetian
patrician Giovanni Falier, a name occurring so fre-
quently and honourably in the history of Canova; and
they are at present the valuable and interesting
ornaments of the villa Falier near Asolo. These
statues he worked in soft stone, while yet only aided
by that vivid and profound sense of beauty and truth,
with which nature had so largely endowed him; and

before his genius had been excited and developed, by the contemplation of the great models of antiquity.

The figure of Eurydice is powerfully expressive of the terror with which she is seized at this fatal moment : she raises her arm as if imploring succour, but her countenance is marked with a full consciousness of her fate, and with the most hopeless grief; her hair falling wildly over her shoulders adds to the distraction of her aspect. The effort is well expressed by which she endeavours to advance, while she is irresistably drawn backwards by a hand reaching out of the smoke and darkness. This figure is evidently a youthful effort, but is valuable from its expression, the deep sentiments it involves, and the hopes which it gave of future excellence. The Orpheus, which so soon succeeded it, shews the rapid progress of the young sculptor : the design and finish of the limbs are better, and the countenance has a nobler expression. It furnishes proof that the important quality of expression, by which the works of Canova were afterward so highly distinguished, was the native and spontaneous growth of his own mind and deep feelings, and needed no foreign aid to call it into being. The attitude of Orpheus, his face turned towards Eurydice, shews that he perceives his fault, and is struck with horror at its dire effects. His steps are arrested, but it is evident that he is free, and has escaped the dark abode. Those

of Eurydice seemed fixed by some superhuman power,
and she is plainly doomed to remain there for ever.

* Canova seems to have preserved always a fond remembrance
of these youthful productions; when the title of Marquess D'Ischia
was conferred on him by Pius XII., he introduced the lyre and
the serpent into his coat of arms.

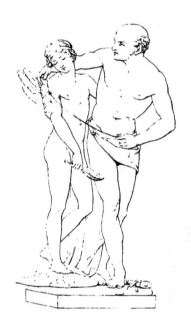

DAEDALUS AND ICARUS

DÆDALUS AND ICARUS.

(A GROUP IN MARBLE.)

" Paternal fears invade his anxious breast,
While his hand trembles, and the sudden tear
Rolls down his aged cheek."

THE imaginative Ovid speaks thus of Dædalus, when
occupied as in the group before us. This famous
Athenian artist being banished from his country on
the charge of killing his nephew Perdix, took refuge
in the island of Crete, where his skill was so highly
prized by the king, that he was not suffered to depart.
The ingenious mind of Dædalus, excited by this re-
straint, formed the design of escaping with his son
through the air, being the only way left open to him;
and he is here represented by the immortal sculptor
of Possagno, employed in forming the wings of the
youthful Icarus, and bending forward in the attitude
of observing if the feathers which he is binding to the
shoulders of his son are fitly disposed. Although
absorbed in his work, yet deep anxiety and sad fore-
bodings are depicted in his countenance; and, perhaps,
too, the appalling voice of conscience, which is ever

more distinctly heard in the critical situations of life, accuses his guilty breast. The innocent son, however, seems pleased at the thoughts of this novel voyage; and, with his head turned towards his shoulder, observes the progress of the work, more impatient for its completion, than attentive to the useful directions of his father. The figure of Icarus, graceful and buoyant with youth and joyous expectations, forms a strong contrast with the dejected aspect of Dædalus, whose mind seems depressed by misfortune. This group, although surpassed by the subsequent productions of Canova, possesses much merit, and was viewed as a presage of his future greatness by the Venetian senate; under their auspices he went to Rome, where he was destined to rise on firmer pinions to a loftier and more secure flight.

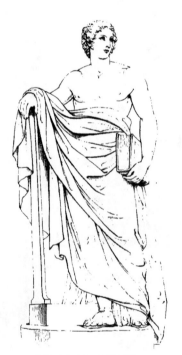

THE DANCING FAUN.

THE MARQUESS POLENI.

(A STATUE IN SOFT STONE.)

———

THIS statue, which is among those which adorn the Prato of Padua, is one of the first productions of Canova's chisel, it therefore possesses the interest that attaches to the early efforts of genius, and as it serves to mark the point from which he advanced to his subsequent perfection.

It is certain, however, that if his own wishes had prevailed we should not have now to notice this work, and his repeated instances prevented its removal to a more secure and distinguished situation, which his affectionate friend L'Abbate D Francisconi, the intelligent librarian of that city would have effected, out of respect to so excellent an artist. It was sculptured so early as 1781 for the Venetian Patrician, Leonardo Venier, as a tribute of affection and gratitude to his great preceptor, the Marquess Poleni, professor of mathematics and astronomy at the University of Padua, and one of the most distinguished men of learning and science of that time.

He is represented in a standing posture, and like the ancient statues of Philosophers, naked, except the lower part of his figure which is wrapped in a flowing mantle; his right hand rests upon a machine invented by him for the purpose of scientific experiment, and his left holds a volume entitled " *De motu aquæ mixto.*" Notwithstanding the comparatively unfinished workmanship of this statue, we may observe in it, that Canova even at that early period duly appreciated the quality of expression, and succeeded in giving to the countenance a look of deep reflection and gravity, and of that kindness of nature which so much endeared this great man to his contemporaries.

THESEUS,

DESTROYER OF THE MINOTAUR.

(A GROUP IN MARBLE.)

———

WHEN the youthful Canova first beheld at Rome those monuments of Antiquity, which raise in the mind so many lofty and interesting ideas, it awakened in his breast the noble desire of being great: the first effort towards which, was the production of his Theseus as conqueror of the Minotaur, a work in which, unaided by the clue of Ariadne, he has overcome the greatest difficulties that surround his divine art.

The Minotaur, a monster deemed by some to have had half the human form, and half that of a bull, but more generally to have the head only of a bull, is here represented by Canova in the latter form, dead, and thrown carelessly upon a stone, from one side of which the head falls down upon the ground, while the legs hang down on the other; his slackened muscles, and the abandonment of his limbs, are full of that expression of lifelessness which denotes the dominion of death. Seated on the lifeless body of the Minotaur, Theseus is taking a moment's repose after the conflict;

his left hand grasping, with an air of triumph, the victorious club, while the right rests carelessly on the thigh of the monster.

Although his exhausted look and attitude shew the arduousness of the struggle in which he has been engaged, yet in his noble countenance there is an air of triumphant satisfaction at the victory which he has obtained; and how great a triumph to destroy, not a private foe, but his country's, and to free it by his prowess from a cruel and degrading tribute.

The figure of Theseus partakes of the ideal beauty, great muscular energy, and power of limbs, an heroical air in his whole person, and above all in his fine countenance. Men who behold this statue would fain resemble Theseus, and the fairer sex experience all the emotions of Ariadne.

PIETÀ

MEEKNESS.

Published for Septimus Prowett July Strand

PIETY AND MEEKNESS.

(MODELLED IN CLAY.)

THESE two figures, allegorical representations of Piety
and of Meekness, were modelled so early as the
year 1783, and intended for the mausoleum of Cle-
ment XIV.; but, as we have already seen in that noble
work, the figure of Temperance was substituted for
that of Piety, and another figure of Meekness, differ-
ing, however, only slightly in respect to dress and
posture, now occupies the place for which this was
designed; so gentle and prepossessing are their de-
meanour, that our love and admiration are deeply
excited, even without reference to the exalted virtues
which they personify. Piety is represented as a female
clothed in a long tunic which falls down to her feet; a
soft and flowing veil covering her head, and descend-
ing in beautiful folds to the ground; there is an ex-
pression of sweetness in her looks which accords with
the spirit of our religion, and of that retired state of
mind so necessary to the conception and enjoyment of
its blessings; wholly abstracted from objects of sense,
her mind seems to be deeply revolving the thoughts of
a more perfect and exalted state of existence.

This figure of Meekness, like that in the tomb of Ganganelli, expresses, by her gentle aspect and modest demeanour, the most entire tranquillity of mind, immoveable alike to the cares, the pleasures, and the passions of the world ; like the other, too, she is sitting with her hands clasped and resting on her lap ; her head is slightly inclining forward, and her hair gathered behind with a graceful simplicity ; large and delicate drapery covers her whole person, and descends in rich folds to the ground ; her presence diffuses a delightful calm over the beholder, which he would do well to improve by opening his heart for the reception of a virtue so rare, and yet so highly befitting our condition.

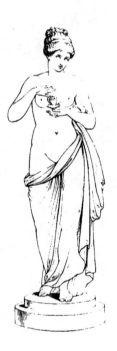

PSYCHE

PSYCHE.

(A STATUE IN MARBLE.)

" In qual parte di cielo in quale idea,
era l'esempio." *Petrarca.*

PSYCHE is here represented by Canova occupied in
holding a butterfly, with the softest touch, between the
forefinger and thumb of her right hand, and placing it
gently in the palm of the left: wholly absorbed in
contemplating the beautiful insect, her features wear a
smile of tranquil and celestial sweetness, expressive of
the sufficiency of the soul, of which both Psyche and
the butterfly are emblems, to its own proper and entire
happiness.

A light drapery of brilliant whiteness and of the
finest texture, which forms an admirable contrast with
the almost natural tints of the flesh, and does honor
even to the chisel of Canova, is folded with a graceful
simplicity around her. But why, O Psyche! conceal
beneath that envious vest thy lovely limbs, when veiled
only in thy ingenuousness and artless innocence, the
thoughts of those who fix their admiring eyes upon
thee, become pure and guiltless as thyself?

PSYCHE.

He who long contemplates, however, this beautiful
symbol of our immaterial part, finds a certain cheerless
and inquiet feeling arising in his mind, that sufficiency
to its own enjoyment chills the heart, and his mind is
led to reflect on the nature of those unsympathising
beings, who having no mutual wants or pleasures, may
enjoy solitary happiness, but can never taste that of
being dear to others.

This lovely nymph, who is about her thirteenth or
fourteenth year, is considered from the purity of the
style, as one of the most Grecian of the works of
Canova; and as the classical style in the arts and in
literature may with propriety be associated, I shall add
a sonnet, which was written by Ippolito Pindemonte
on beholding this statue.

SONNET.

Those youthful limbs, that bosom's growing charm,
 That face where beauty's flower expands to light,
And gazes on the bright winged insect form,
 The symbol of the soul's immortal flight ;
So true to nature has the sculptor wrought,
 That fain the future Psyche would we see,
When the fair form with sprightly vigor fraught,
 And the full bosom reach maturity.
Love hovers round her, and enraptured views
 The early promise of that lovely face,
To him the destined source of many woes ;
 In this chaste marble all her charms we trace,
Nor envy we what Greece or Rome bestows,
 When works so fair our golden era grace.

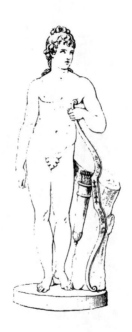

CUPID

CUPID.

(A STATUE IN MARBLE.)

POET, sculptor, or painter, has rarely been found in-
sensible to the fascinations of this young deity, or
neglectful in doing homage to him by his peculiar art.
In this image of the charming son of Venus, the
beauty and purity of design, and that exquisite
delicacy of touch which is the highest effort of sculp-
ture, and produces its most enchanting effects, are
equally to be admired; his gentle form and limbs
possess that early and unformed beauty which is
proper to his age; his luxuriant locks are divided into
short curls, and fall down behind to the point of his
shoulders, giving a soft lustre to his beautiful counte-
nance; and in forming the lips, which are somewhat
full and dilated at the extremities, with an expression
of great sweetness, the sculptor's hand seems to have
been guided by the most empassioned feelings; he is
standing in an easy and graceful attitude beside the
trunk of a tree, on which he has hung his quiver; in his
left hand he holds his irresistible bow, and the other,
falling down his side, rests on his hip, with a charming
expression of youthful grace; his calm and reposing
posture, his bow unstrung, and quiver laid aside, and

above all, the gentle and serene expression of his features, in which no threatened mischief lies, all indicate that the sculptor would here express that tranquil and delightful state when love, viewing with complacency the effect of his last shaft, permits to his votary a delightful interval of constancy and repose.

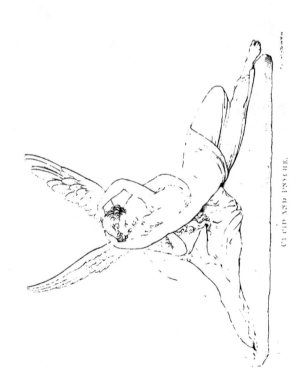

CUPID AND PSYCHE.

CUPID AND PSYCHE.

(A GROUP IN MARBLE.)

THE most difficult task that the anger and jealousy of Venus prompted her to impose on the unfortunate Psyche, was that of the descent to Erebus, to obtain of Proserpine a portion of her charms, as women are every where jealous, above all things, of their beauty, as the source of the unlimited homage which they enjoy; but Cupid, who with unceasing care watched over the perilous destiny of his fair mistress, inspired her with the means of succeeding in the dangerous embassy. Psyche thus having obtained the gift of Proserpine, had no sooner emerged from the gloomy realms of Pluto into the cheering light of day, than an irresistible curiosity arose in her mind to see the contents of the box in which her charge was contained. Seating herself therefore on a stone, she raised the fatal lid, but instead of aught that can charm or delight, a dense and pestiferous vapour issued from it, which deprived her of sense, and she fell lifeless on the earth. Cupid by this time had flown to her succour, and by his efforts recalled her to life.

CUPID AND PSYCHE.

Canova has taken the moment when the beautiful Psyche, recovering from her insensibility, throws back her lovely head, from which her charming tresses fall down in richly flowing ringlets, and opens her eyes on her beloved husband ; he, resting one knee upon the ground, and bending over her, gazes with rapture in her beautiful face, his left hand tenderly encircling her, and reaching to her swelling bosom, while with the other he supports her lovely head : his tender and entreating attitude is that of one who sues for a kiss, which in other moments has not been denied to him, while she, consenting with equal fondness, raises her arms, and placing her hands caressingly on his head, draws gently his lips towards her own.

Surely the virgin graces, and the innocent loves, gave all their aid to Canova while forming this charming composition ; and with such tender and subduing sensations does this lovely pair, so enchantingly grouped, affect the beholder, that his heart is disposed at that moment to love every object that is dear to him with encreased affection.

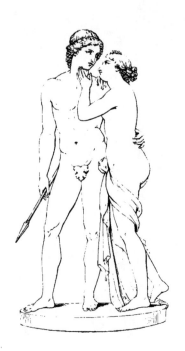

VENUS AND ADONIS

VENUS AND ADONIS.

(A GROUP IN MARBLE.)

———

In this group Adonis is represented in the attitude of leaving Venus and setting out for the chase; while she, leaning on his shoulder in all the abandonment of passion, endeavours by her caresses to detain him. The figure of Venus is full of softness and voluptuousness, and the gentle and graceful action of that hand which fondlingly touches the cheek of her lover, would alone be sufficient to reveal the Goddess of Beauty; a scarf, which is her only dress, forgotten at such a moment, is falling down from her waist. Adonis, who is hastening away to the fields, throws his arm around her, and takes a parting glance; but how languid the pressure of that embrace! how unconcerned that look! On her part there is the tenderest and most devoted affection, while his aspect expresses only the cold, and, under such circumstances, ungrateful sentiment of the recollection of past happiness.

This delightful group must command the admiration of every one, but will be least pleasing to

our sex, who cannot endure, even in marble, that the sentiment which they inspire should be weaker than that which they themselves experience, and if this subject had been treated by a female artist, undoubtedly, Adonis would have been the supplicant. It is generally felt that the figure of Venus, notwithstanding the seducing softness of her limbs and the loveliness of the features, heightened as it is by the expression of gentleness and affection, is yet not so strikingly beautiful as that of her lover. Is this because she is in the attitude of solicitation? Gentle dames! What a lesson is this for us, and what can we expect when it is necessary to sue, if Venus herself, in so doing, loses her attraction.

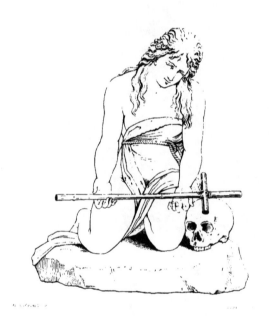

THE MAGDALEN.

Plate 1

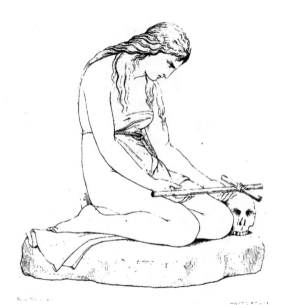

THE MAGDALEN.

Paris.

London Published by Longman & Co.

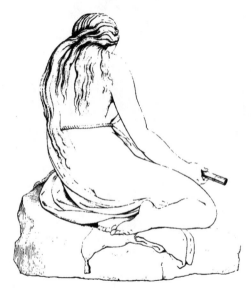

THE MAGDALEN

THE MAGDALEN.

(A STATUE IN MARBLE.)

THE beautiful and penitent Magdalen has, in all ages,
powerfully excited the fancy of the artist, and was, in
particular, a favourite subject with many of the great
masters of the pencil. Twice had Canova sculptured
the Magdalen, in a kneeling posture, and with an
expression of such utter sorrow and contrition, that it
might have been thought that he had wholly ex-
hausted his imagination on it; but in this statue we
again behold the same subject, treated with new and
admirable features, although representing the same
epoch of her life, and sentiments of the same character
as the former. This sublime figure lies stretched su-
pinely upon a rugged stone, the lower part only of her
person covered with a loose garment, and forming, by
her position, a flowing line that produces a delightful
effect; her eyes filled with tears, are raised towards
heaven, with a look which expresses that her thoughts
are wholly alienated from earth, and centred there:
her unbound tresses fall neglectedly over her shoulders
and bosom, and her arms are listlessly extended besides
her; the right hand holding a cross which rests upon her

shoulder; the other hand with the palm spread as in the act of prayer. Her person, although wasted, still shews the reign of youth, and of those charms which nature had so largely bestowed upon her, but so sunk by langour and mortification, that we wonder how marble could be made to assume such attenuated forms. A slow and feeble respiration seems to pass along her delicate neck, which is distended on one side by the posture of her head, and gives token that life still weakly animates her frame. This lovely and pathetic figure is wholly the offspring of Canova's imagination; no where else could he have found a model of such sorrow, such piety, such deep and sincere repentance.

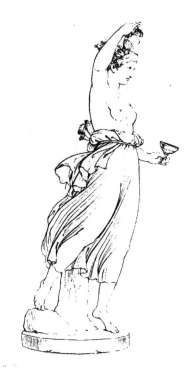

HEBE

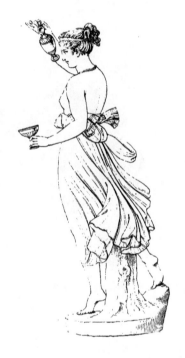

HEBE.

HEBE.

(A STATUE IN MARBLE.)

WE welcome this lovely cup-bearer of Jove, the
charming goddess of eternal youth, as if she had
just descended from the skies, and feel inclined to
address her in the words of our elegant poet, Ippolito
Pindimonte :—

> Whither celestial Hebe do'st thou stray,
> Leaving the banquet of eternal Jove ;
> Deign'st thou to change the radient fields above,
> To tread earth's darker and ignobler way?
> Immortal sculptor who do'st yet outvie
> Italian art, and reachest attic grace,
> Life's soft and breathing aspect thou couldst trace ;
> Here sculptur'd motion cheats the wond'ring eye.
> Back from that form on which entranc'd we gaze,
> Her vestments seem to flutter in the wind,
> Buoyant in many a graceful fold behind ;
> While Nature's self, whose law the world obeys,
> Deceiv'd by mimic art, believes a stone
> With motion gifted, swiftly passing on.

The light drapery which clothes her, knotted grace-
fully round the waist, descends below the knee and
leaves uncovered her delicately moulded shoulders and
swelling bosom; this soft dress is pressed by the buoyant

wind against her person, and partly reveals to us the beauties of her perfect form. What divine movement! what delicate limbs!—Never, I think, has Canova more felicitously expressed the soft, the warm, the living hue of beauty: an elegant diadem adorns her forehead, partly confining her clustering ringlets, which are gently lifted by the breeze: her attitude is that of pouring out nectar from a golden vase, which she holds raised in the right hand, into a goblet of the same metal in the left; her expression is joyous, but composed, as if intently performing her office in the presence of the assembled deities.

We contemplate this pleasing figure with the same avidity that we look on an enchanting object which is passing away in rapid flight, and feel from this illusion a heightened and more lively pleasure.

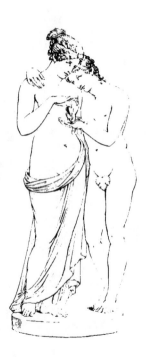

CUPID AND PSYCHE.

PSYCHE AND CUPID.

(A GROUP IN MARBLE.)

THE ancients, to whom we are indebted for this beau-
tiful allegory, have also transmitted down to us a
charming group, in which the union of Cupid and
Psyche is represented. The simplicity of the subject
is such, that little seemed left to those who should
attempt to treat it again, than to copy the beauties of
old models. Canova has managed, however, although
the peculiar merit of the sculptor lies in execution
rather than invention, to give to his work new beau-
ties, both as regards its pleasing and varied expression,
and also the attitudes of his incomparable figures; they
are standing, half embraced, fronting the beholder,
with the exception of their faces, which being turned
inwards to each other, are seen in profile. Cupid,
who is shorter in stature than his mistress, passes his
right arm round her neck, and rests his cheek fond-
lingly on her shoulder, the other hand opened, is held
up to receive the mysterious symbol; Psyche, holding
the beautiful insect by the closed wings, between the

fore finger and thumb of her right hand, and carefully guiding that of her lover, places it tenderly on his palm, and hangs gazing over it, wrapped in pleasing contemplation of her own pure and transcendant nature.

The son of Venus is naked ; Psyche is, however, wrapped round with a light vest, which falling in large folds over her lower limbs to the ground, serves as a support to the whole group. We behold with admiration the delicacy, the harmony, and grace of their exquisite forms ; the fine and varied expressions of their countenance, which seem to partake of their pure and exalted nature ; that beautiful hand, too, which detains the butterfly, is full of harmonious expression, and acts like a charm on our senses. Canova has bestowed on the figure of Psyche, the distinguishing attributes of the refined nature of which she is the emblem ; her loftier stature—the nobleness of her aspect—the pure joyousness of her smile—and lastly, her erect attitude, which so finely contrasts with that of Cupid, who, tame, languid, and submissive, as if controlled by her superior nature, would scarcely be recognized amidst these unusual attributes, if not seen united with the celestial Psyche.

PERSEUS.

(A STATUE IN MARBLE.)

THE intrepid son of Jupiter and Danae having engaged
to bring to Polydectes, king of Seriphos, the head of
Medusa (the only one of the Gorgon sisters who was
mortal), was armed by the different deities for the exe-
cution of this daring exploit. Medusa was cele-
brated for her charms, and in particular for the beauty
of her hair, but having offended Minerva, part of her
tresses were changed into serpents by the vengeful
goddess.

Perseus is here seen in the moment of victory; in his
left hand is displayed the bleeding head of the Gorgon,
which he holds up by the locks, while his right still
grasps the deadly falchion; he is naked, except the
loose drapery which hanging from his arm trails upon
the ground; on his head is a winged helmet, shaped
like the Phrygian cap, the gift of Mercury, and
sandals clothe his feet. The sculptor has given to
this statue a noble and elevated style of beauty, and
an air of divinity which raises him above the rank of
mere mortals, and finely accords with the descriptions
of the heroes and demi-gods of mythology. The

countenance of Medusa possesses at once a beauty and a horror which is more than human—which, even in this stone, exercises a sort of fascination over us, and aids the imagination in forming an idea of its original power; her distorted features have not yet wholly lost the power of expression, and seem, even while we gaze on her, to be gradually subsiding to the impassive aspect of death; a wonderful effect of art, in which the excited imagination of the beholder connects the past and the future with the actual state of the object before him.

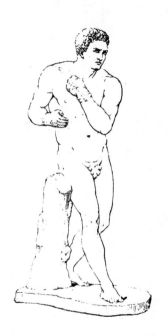

DATOGNER

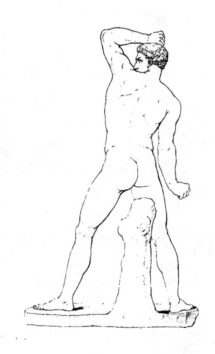

CRITIAS

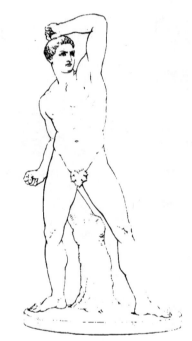

CLEOMAS
Rome

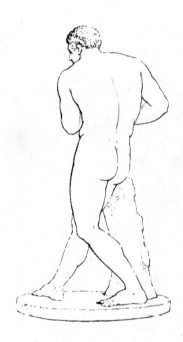

DANDANUS

CREUGAS AND DAMOXENUS.

(STATUES IN MARBLE.)

THE delight which the ancient Greeks took in the cruel
contests of the athletæ, appears to be inconsistent
with the general refinement of their characters, which
a beautiful country and genial climate, their wise
laws and forms of society, all tended to humanize and
exalt; and it is, perhaps, a proof of the degrading
aptitude which exists in human nature to become
familiar with, and even to take pleasure in cruel and
sanguinary sports: among these, the combat of the
pugilists was the most fatal and revolting, as the
victory of the successful combatant was not complete
without the avowal of defeat by his antagonist, which
their obstinate courage usually delayed until all
strength, and even until life itself was almost gone.
The combat between Creugas and Damoxenus, which is
recorded by Pausanias, is distinguished by its peculiarly
brutal and revolting character. These Argives and pugi-
lists, of remarkable strength and courage, were contend-
ing at the Nemean games, their hands strengthened
with leathern thongs in the usual manner, when victory

remaining long undecided, it was agreed that each combatant should alternately give a blow to his antagonist, and receive one from him in return. Creugas, having to give the first blow, struck his adversary on the head, but without any decisive result : Damoxenus, before returning the blow, required that his adversary should place his left hand on his head, which being done, he drove his armed hand into the exposed side of Creugas, and penetrating to his entrails, tore them reeking from his body; the unfortunate Creugas fell and expired on the spot. His pitying countrymen placed the olive crown upon the head of the dying Creugas ; and, struck with horror at the deed, condemned the ferocious conqueror to perpetual exile.

The combatants are here represented at the moment when Creugas, having first struck his adversary, stands with his unarmed hand raised to his head waiting for his blow in return; the rigidity of the muscles produced by this posture, and his exposure to the savage design of Damoxenus, is shown with such truth and force of expression, that, although our imaginations can with difficulty reach the height of the brutal fury and excitement of the athletæ, we feel a deep sense of the terrible effects of the blow which he is about to receive. The sculptor has united, in the figure of Creugas, the athletic character with great beauty of form ; his features are regular, but a severity of ex-

pression is given to them by the violent emotions by
which he is possessed; there is, however, something
in his aspect which propitiates us in his favour, and
creates an anxiety for his fate. Damoxenus, although
of larger and more Herculean mould, is also finely
proportioned; his attitude is that of one who is col-
lecting all his strength to give a deadly blow, and
in his features are plainly revealed his brutal and
sanguinary character.

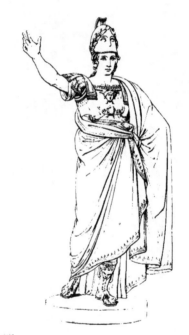

FERDINAND IV KING OF THE TWO SICILIES.

FERDINAND IV.

KING OF THE TWO SICILIES.

(A STATUE IN MARBLE.)

———

THIS magnificent colossal statue presents to us, in its
majestic countenance, a striking portrait of the mo-
narch who is seated on the throne of the two Sicilies.
The costume is in the heroic style: the helmet worn
with the vizor raised, is encircled with a laurel wreath,
from behind which a lock of hair falls down symmetri-
cally on either side. The cuirass is elegantly adorned
with figures, and displays on the breast a winged
gorgon head. A splendid mantle hangs on his left
shoulder, and passing under his right arm is gathered
up on the left side by his hand, and which, together
with the arm it wholly conceals, falling down thence in
elegant folds to the feet, on which are highly orna-
mented sandals. His posture is that of one in the act
of haranguing, the right hand being extended forward
and open. His countenance is grave and composed,
but expressive of the mildness of his character, and
suggests that some extraordinary circumstances must
have led to this warlike representation of the pacific

monarch. Nothing can exceed the expression of life and nature in the look and attitude of this statue, the elegance and facility of the execution, or the graceful flow of his sumptuous dress; so skilfully is this disposed, that it is not only not productive of confusion to the eye, but exhibits an admirable model of the union of the richest drapery with a fine and accurate developement of form. The general effect of this statue is excellent, and viewed from any point presents to the eye a pleasing and harmonious outline.

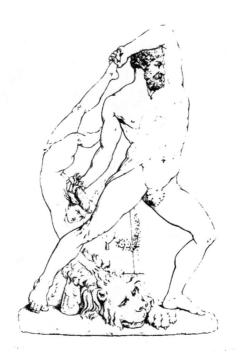

HERCULES AND LICHAS

HERCULES AND LICHAS.

(A GROUP IN MARBLE.)

———

THE gigantic figure and immense strength of this
Hercules surpass the loftiest ideas that our imagi-
nation had formed of that celebrated hero of mytho-
logy. He has just clothed himself in the fatal vest,
dipped in the blood of the Centaur, which Dejanira
sends to him by the youthful Lichas as the means of
regaining his love; the effect of the poisoned garment
is soon felt; he is seized with sudden agony, and
blindly vents his fury on the innocent messenger:
seizing the unfortunate Lichas by the sole of the foot,
he has whirled him behind his back, to give the
power of the sling to his throw, and looks out fixedly
towards the sea as if to gratify his rage by marking
the distant spot where his victim will plunge into the
waves. The features of Hercules, although distorted
by the fierce pain which consumes him, preserve that
dignity of aspect which the great masters have always
observed even in depicting the severest bodily or
mental suffering. The hapless Lichas clinging vainly
to an altar for protection, exhibits all the appearances
of the most violent terror, and seems to utter the most
piercing shrieks.

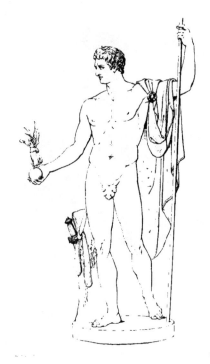

NAPOLEON

NAPOLEON.

(A COLOSSAL STATUE IN MARBLE.)

———

THIS fine statue belongs to the heroic style, and is of colossal dimensions; little ideal effect has been added to the countenance, in which resemblance to the original has been preserved as closely as the nature of the work would allow. His ample forehead—the look of deep and intense thought—the strongly marked expression of his mouth and chin, all indicate a personage of high and extraordinary qualities. Like the Cæsars he is represented naked, excepting a rich military cloak which hangs down from his left shoulder. In his right hand he holds a globe surmounted by a victory, while the left, raised above his head, grasps the imperial sceptre; he inclines his head towards the figure of Victory, and seems absorbed in the emotions of stern delight which it excites. His left foot is raised as if in the attitude of moving forward, and finely accords with the animated and eloquent expression of his countenance; the neck and chest are sculptured with much grandeur of style, and in every part of this magnificent statue we discover beauties which attest the scientific skill of the sculptor.

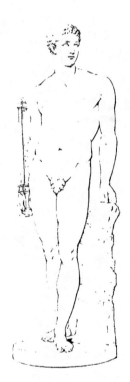

PALAMEDES

PALAMEDES.

(A STATUE IN MARBLE.)

THE story of the young hero whom this noble statue represents, can only be imperfectly traced through the obscurity of the early ages of Greece, and of poetic fiction. All accounts, however, agree in describing Palamedes as a man of an acute and comprehensive mind, of great wisdom, firmness, and humanity; the report of Plato is not a little to his honour, that Socrates, when about to die, said, he rather rejoiced that he was going to join the departed heroes of Greece, and among them the celebrated Palamedes, who, also, had been unjustly condemned to die by his country. The artists of ancient Greece supposed that moral perfections were always connected with symmetry of form and beauty; and Canova, following these consummate masters, has given to the image of this distinguished man great beauty of form and countenance, and a stature somewhat loftier than that of nature. He is standing in a natural and easy posture beside the trunk of a tree, against which he slightly rests his thigh; the right hand, falling gracefully down his side, sustains a parazonium, on the

sheath of which are ingeniously introduced the five characters which he is said to have added to the alphabet; the other hand, resting lightly on the trunk, gives firmness to his attitude; supporting himself chiefly on his right foot, his left shoulder is slightly raised, and great ease and flexibility is given to his whole figure. His neck and back, though muscular and shewing great strength, are sculptured with an admirable pliancy and truth. The countenance strongly and finely expresses the character of this hero; wisdom, acuteness, and a look of equanimity which indicates the absence of all violent and uneasy passions, and gives that tranquillity so necessary to true and perfect beauty. He is, it is said, the author of the game of draughts, which he invented to relieve the tediousness of the seige of Troy.

Shortly after the completion of this noble statue, Canova was examining his work with the severe scrutiny of an anxious parent, when its support giving way, it fell to the ground, and the artist narrowly escaped from being crushed beneath it. Although broken into many pieces, yet the fine taste of him for whom it was executed did not fail still to appreciate its value and to claim it.

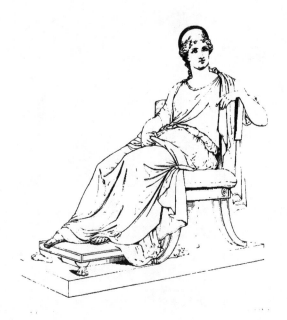

MADAME THE MOTHER OF NAPOLEON BONAPARTE.

MADAME,

THE MOTHER OF NAPOLEON,

(A STATUE IN MARBLE.)

———

In contemplating this fine statue, which seems to live, and has the aspect of a divinity, we behold an admirable specimen of the powers of the divine art of sculpture, when exercised by consummate genius.

Canova has represented the mother of Napoleon, attired in the Grecian costume, sitting in an easy and graceful attitude upon a seat of a classical form, and resting her feet upon an elegant footstool: her fine countenance, which strikingly resembles the original, and her whole person expressing the greatest majesty. The head is slightly turned to the left, with an air of sweetness and composure, and the left arm resting with negligent dignity on the back part of the seat, while the right hand holds gracefully the collected folds of her flowing mantle. The feet and the hands are exquisitely sculptured. In her noble countenance we perceive that the freshness of youth has yielded up its rights, and given place to the matronly aspect of mature years: it is serene, yet slightly animated by

some lofty and gratifying idea, which seems entirely to occupy her mind; and while the beholder, imagining what pleasing subject employed her thoughts at that moment, is led to reflect on the disastrous changes which have since befallen her house, he is prompted to exclaim—this sculptured marble, at least, is exempt from the vicissitudes of fortune! here alone the smile of prosperity is lasting!

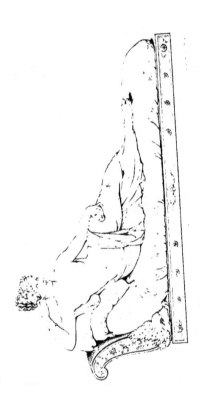

/

VENUS VICTORIOUS

VENUS VICTORIOUS*.

(STATUE IN MARBLE.)

THE three species of power which have ever been considered as exercising the greatest control on the affairs of the world, are those of Strength, Intellect, and Beauty; but strength of body yields to intellect, and both united, it must be allowed, vainly oppose the power of beauty, which, by its influence on the heart, subdues all mankind. Perhaps the Greeks contemplated this three-fold division of power in their deities, Juno, Minerva, and Venus, who, in order to decide their respective pretensions, presented themselves to the Phrigian shepherd on Mount Ida: by his decision Venus gained the apple, and the title of Victorious.

The artist wishing to represent the goddess in all the self-complacency of her triumph, has collected every attractive charm, that memory or fancy could supply, to diffuse them over this exquisite figure; and as the attitude of repose is, at the same time, the most voluptuous, and the most advantageous to

* The head of this statue is a portrait of the Princess Borghèse.

the display of form, he has represented her reclining
on one of those Grecian couches which the revolu-
tions of fashion have lately brought into use again.
The bust of the lovely goddess is raised and sup-
ported on the right side by elegant cushions, upon
which the upper part of the arm rests with graceful
ease; while the lower part, encircled by a bracelet,
is bent towards the head, to which the hand serves
as a support: the other arm is extended forward,
resting upon the thigh, and the hand slightly turned
inwards, holds gracefully the contested apple, which
the goddess regards with a complacent aspect.
This graceful attitude presents to our admiration a
soft and voluptuous bend in the left side, the effect
of which is as charming to the spectator, as its execu-
tion must have been difficult to the sculptor.

While gazing on this enchanting object, a de-
lightful illusion takes possession of your senses; you
fancy that it is animated with life—that you see it
breathe, and, in the agitation of your feelings, entirely
forget that you gaze on inanimate marble.

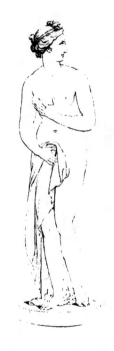

VENUS.

VENUS.

(A STATUE IN MARBLE.)

———

ALTHOUGH the modesty of Canova would not allow
him to undertake the restoring of the arm of the
Medicean Venus, when urged by the united wishes
of his country, yet he has since presented to Italy a
Venus, which, without creating a rivalry with the
ancient statue, has done much towards reconciling it
to the departure of that highly valued guest; with the
scrupulousness which ever accompanies true modesty,
he has, however, made it a condition that it shall not
occupy the place which had been made vacant in
the gallery of Florence by the absence of the Grecian
Venus.

In treating a subject so congenial to his taste,
he has followed no model, nor taken any other guide
than his own exquisite idea of female beauty. The
dimensions of his statue are somewhat larger than
those of the ancient figure; she is in the graceful and
attractive posture of one who issues dripping from
the bath, when the freshness of the limbs, and the soft
brilliancy of the skin, add an inexpressible charm to
beauty. This delightful appearance has been lost (if

indeed it was ever possessed) by the Venus De' Medici,
whose present surface impaired, perhaps by long ex-
posure to the air, or by the substances in which it has
lain buried, contrasts with the porous and transparent
skin of Canova's Venus very much to the advantage of
the latter, but a comparison of these admirable
works—

" È d'altr' omeri soma, che de' miei."

I shall content myself, therefore, with noticing here
some of the excellencies of that of Canova. She is
standing in a natural and elegant posture, bending
slightly forward, and pressing to her breast a cloth
with which she is about to dry her limbs, and which,
falling down in large masses to her feet, veils the
front of her person, and gives the necessary support
to the statue; the right hand and arm are enveloped
in this drapery, which is executed with such skill
and delicacy that their forms are scarcely concealed
by it; nothing can be more graceful, animated, and
tender, than her beautiful face, turned towards the
left shoulder with an air of awakened attention, as if
some agreeable sounds, perhaps the approaching car
of Mars, had just caught her ear; there is a seducing
softness and eloquence in her looks, the conferring of
which seems to lie beyond the limits of art, and which
creates in us, while we gaze on her, the strongest and
most delightful illusions; it is in forming the eye,

perhaps, that Canova applies with the most entire and complacent attention the force of his genius, giving a reality and a charm to his expression, which is the highest and rarest effect of art.

It may be objected to the Grecian sculptors, that they have always given to the features of this goddess a tranquil and unimpassioned expression, inconsistent with the light and pleasurable emotions over which she was supposed to preside, and with the quick and susceptible nature of the Greeks themselves; for although the expression of the violent passions is forbidden in the arts, as tending to alter and deface the fine and delicate lines of beauty, yet the animation which is given by the softer and more joyous emotions, adds, on the contrary, greatly to female charms. Canova, in giving to the features of his enchanting Venus a divine animation, seems to have aimed at avoiding this objection.

But it is in vain that I would describe the sweet smile which plays upon her lips—her finely formed neck—her beautiful bosom—charms on which the eye insatiably dwells, until the marble image grows warm and breathing to our cheated senses.

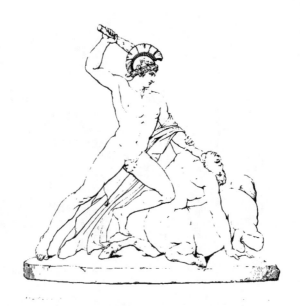

THESEUS SLAYING A CENTAUR.

THESEUS

SLAYING A CENTAUR.

(A COLOSSAL GROUP IN MARBLE.)

———

THIS superb composition represents, in a colossal
group, Theseus in the act of slaying a Centaur. The
son of Egeus is at that propitious but fleeting period
of life, when the bodily powers being fully deve-
loped and confirmed, man appears in all the pomp
of strength and beauty which nature destines for him.
His attitude shews fully his handsome and noble
person, the front of which is presented to us, with
the exception of the head, which being turned
towards the monster, who is sinking beneath his
blows, is seen in profile: a splendid helmet adorns
his head, from under which his hair escaping, curls
luxuriantly over his forehead; with his left hand he
holds, in a strangling grasp, the throat of the Centaur,
while his right hand, armed with a ponderous club,
is raised in the act of completing, by a deadly blow,
the destruction of his enemy; who supporting him-
self with his left hand on the ground, tries vainly

with the other to remove the fatal hand of his conqueror. The knee of the hero, gaining force from the foot, which rests against the ground, is pressed violently against that part of the body of the Centaur, where, with wonderful art and an union that seems almost natural, the beast ends, and the human form begins. Although the face of the monster expresses strongly the terror and distress with which he expects the final blow, yet his fine gigantic form shews all the vigour of existence, and with so natural an effort do his hind legs, which are violently bent under him, endeavour to recover themselves, that forgetting that it is stone, we almost expect to see him spring upon his feet again.

Animated ourselves at the arduous combat, we observe with admiration the tranquillity of the hero himself, whose eyes are fixed on the monster with a countenance unmoved either by anger or triumph, as if such deeds and greater were familiar to him.

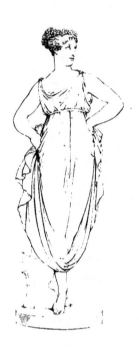

DANCING GIRL.

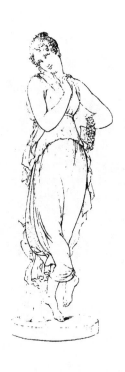

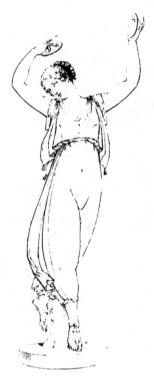

DANCING GIRL

DANCING GIRLS.

(STATUES IN MARBLE.)

THE dance is, perhaps, the strongest demonstration of
joy, and, united with music and poetry, has ever been
used in the celebration of the festivals of all nations.
The early sculptors did not neglect this fruitful source
of lively and joyous emotions, and took pleasure in
representing it in all its varied and delightful forms.
Among the moderns, our Canova, if his genius does
not rather entitle him to be classed among the
ancients, has produced these three dancing girls, so
sprightly and beautiful that they might well have
been mistaken for the Graces themselves, if their
attitudes had not revealed the intentions of the
sculptor. From their general resemblance, they all
seem to have sprung from one idea, which the artist
was willing to try to what degree he could vary, by
bestowing peculiar graces of attitude and expression
on each.

The figure which I call the first, on account only
of the order in which I shall mention it, is in a less
voluptuous attitude than her companions; she is
beginning the dance, and has gathered up her long

and elegant dress to give the necessary freedom to her feet, in doing which, she displays her finely proportioned limbs to advantage; her face, which is turned towards the left shoulder, is beautiful and serene, and the smile which slightly separates her lips, with a corresponding glance, tends to create in us the most pleasing illusions. This beautiful pupil of the Graces, tinging the objects which surround her with her own vivid hues, excites gaiety and joyous thoughts in all who behold her.

The attitude of the second figure is that of taking repose after the exertion of the dance; the right foot is carelessly thrown over the left, which is planted against the ground, and gives firmness to her posture. The left hand, which has hanging on its arm a chaplet of flowers, rests against her side; the other is raised to the face, and touches the cheek, which inclines towards it with a soft and expressive grace. The neck, the arms, and her agile feet are uncovered, and prove, by their fine execution, the accuracy of the artist, and the devotedness with which his genius was applied to this work. Unlike the light elastic figure of her companion, there is here the abandonment of limbs, which is the consequence of fatigue; her countenance, although without the gaiety of the former, is equally beautiful, and breathes a soft and voluptuous expression.

DANCING GIRLS.

The third figure is seen in the midst of the sprightly dance, which she animates with the sound of the cymbals, held elegantly up over her head; she is clothed in thin drapery, which does not, however wholly conceal her delicate and finely formed limbs, and her feet are adorned with elegant sandals.

To which of these three beauties a Paris would award the preference, I cannot decide; Canova, in giving them equal, though various attractions, intended, perhaps, to gratify the variety of tastes which exist in this respect; for my own part, I should rather prefer the first, being ever disposed to adorn our short and doubtful existence with joyous and enlivening thoughts, which, scattering fresh and fragrant flowers along the path of life, enliven and improve our transient existence.

THE PRINCESS LEOPOLDINA ESTE HAZY.

PRINCESS LEOPOLDINA ESTERHAZY.

(A STATUE IN MARBLE.)

THE beauty of the Grecian youth, to which that fine climate was so favorable, greatly contributed to the high degree of perfection to which the fine arts attained there, and which, perhaps, will never be reached by any people living under a less propitious sky; there, the imagination of the artist, aided by the sight of female charms, like those of the Princess before us, formed those perfect ideas of beauty, which, embodied in their exquisite figures of Venus, have ever commanded the admiration of their posterity.

With all the charms of youthful beauty and graceful manners, the Princess Leopoldina could not fail to kindle the fancy of our great sculptor. He has represented her rather above the natural size, sitting on a rustic seat, and exercising her elegant talent for landscape painting; the left foot, on which is an elegant sandal, is extended forward, while the right being drawn in, gives a graceful ease to her attitude; her head is slightly turned toward some object that she is about to sketch on her tablet,

which, held in her left hand, is supported on her lap, while the right hand, resting against her side, holds the pencil in readiness to obey her dictates : from the graceful animation of the head, and the sprightly but attentive expression of the countenance, it seems that some delightful landscape lies before her which she is going to sketch. Her beautiful tresses are disposed with that elegant carelessness which distinguishes the heads drawn by the rapid and graceful pencil of the famous Madame Le Brun. She is clothed in a tunic, which, only fastened on the shoulders by a clasp, and gathered round the waist by a narrow band, leaves uncovered her finely formed arms, the shoulders, and part of her beautiful bosom, and although falling in rich folds, yet by its skilful arrangement and adaptation to the person, reveals the charms of her light and elegant figure ; a flowing mantle is gracefully thrown over this, forming, with the tunic, a mass of beautiful drapery, yet disposed with so much art, that the folds of the different dresses are never confused or undistinguishable to the eye.

So gentle and lovely is her whole aspect, that in my admiration I exclaim, Happy Father! to be able thus to preserve the form, too bright to last, of a beloved daughter from the unsparing hand of time, and by the genius of a modern Praxiteles, leave to posterity this memorial of her loveliness and of thy paternal affection.

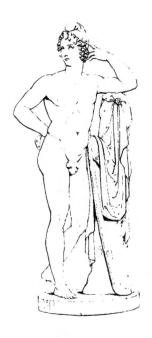

PAPIS

PARIS.

(A MARBLE STATUE.)

———

PARIS is described by Homer as being " beautiful as
a God," and it seems to have been reserved for
Canova fully to interpret the inspiration of the Poet.
What symmetry! what grace! what ingenuousness of
aspect! Among all the productions of his genius, we
should not hesitate to give to Paris that same pre-
ference which he is about to bestow on Venus; but
that, unlike the contest on Mount Ida, where one
only was perfectly beautiful, the more difficult task
here presents itself of deciding among the many
equally admirable works of our artist.

Paris is standing and leaning against the trunk
of a tree on his left arm, the hand of which is raised
to his head, and his dress, which has all the elegance
of Grecian drapery, is hanging beside him. His
attitude is easy and graceful; and how finely does that
soft voluptuous bend of the head express the pleasure
and self-complacency with which he exercises the
office of arbiter in such a contest. In his right
hand, which is resting behind him, is seen the golden

apple, but partly concealed, as a presage, perhaps, of
its fatal consequences. His clustering ringlets, which
are only partly covered by his shepherd's cap, shade
and adorn his open forehead and his polished cheek.
On whatever side we observe this figure, we discover
nothing but beauties and perfections; designed with
purity and finished with great truth and effect, this
statue possesses eminently that charm which belongs
more or less to all the works of Canova, but which
still never fails, in every new instance, to surprise and
delight us.

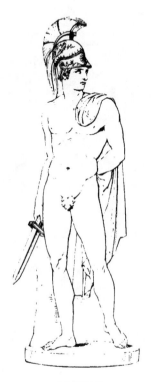

HECTOR

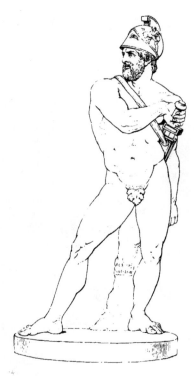

AJAX

HECTOR AND AJAX.

(STATUES IN MARBLE.)

THIS subject is taken from the seventh book of the
Iliad. Helenus, inspired by heaven, counsels Hector to
suspend the fight and to defy the Grecian chiefs to a
single combat. They, by direction of Nestor, cast lots,
which determine in favour of Ajax; after having con-
tended with javelins they cast them aside.

> " And now both heroes their broad falchions drew:
> In flaming circles round their heads they flew;
> But then by heralds' voice the word was given,
> The sacred ministers of earth and heaven:
> Divine Talthybius, whom the Greeks employ,
> And sage Idæus on the part of Troy.
> Between the swords their peaceful sceptres rear'd;
> And first Idæus' awful voice was heard:
> Forbear, my sons! your farther force to prove,
> Both dear to men, and both belov'd of Jove.
> To either host your matchless worth is known,
> Each sounds your praise, and war is all your own.
> But now the night extends her awful shade;
> The goddess parts you: be the night obey'd.
> To whom great Ajax his high soul express'd:
> O sage! to Hector be these words address'd.

HECTOR AND AJAX.

Let him who first provok'd our chiefs to fight,
Let him demand the sanction of the night;
If first he ask it, I content obey,
And cease the strife when Hector shows the way."

Pope's Iliad.

The combatants are represented at the moment
when Hector, having drawn his sword, sternly eying
his foe, awaits the attack of the Greek, who, with a
menacing look, is drawing his weapon from its sheath.
In the aspects, figures, and attitudes of each, we find
the dissimilar characters of these celebrated warriors
finely and distinctly marked. The look of the illus-
trious son of Priam awakens in us that deep sym-
pathy with which we follow him through all the
vicissitudes of war, and particularly in the scenes of
domestic gentleness and affection; while that of the
Greek excites the admiration which we cannot with-
hold from high courage and hardihood. The Trojan
prince is distinguished by his fine countenance, his
noble aspect, and a figure which, although it promises
great strength, corresponds with the character of the
lofty-minded Hector. With tranquil courage, the inse-
parable companion of valour, he waits for his adversary
to draw his sword, in order to commence the attack.
On the other side, the fierce Ajax, his large and mus-
cular frame breathing immense vigour, stands in the
act of drawing his sword from its scabbard, and casting

a ferocious glance on his adversary, seems already to triumph in his destruction. These two almost colossal figures may be referred to among others to prove that it was not in subjects of gentleness and beauty alone that Canova excelled, but that in the expression of the violent and terrible passions he has equal claims to our admiration.

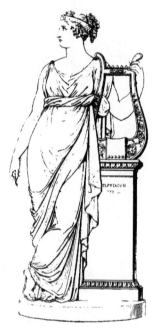

TERPSICHORE.

TERPSICHORE.

(A STATUE IN MARBLE.)

———

THIS Muse (whose name in the original signifies the love of the art over which she presides) is in the possession of Count Sommariva, at Paris; and, together with a Cupid and a Magdalen of Canova, form a part of the gallery of that noble Milanese, who is equally distinguished by a fine taste in the arts, and by his kind and condescending manners. Terpsichore is standing beside a short column, against which she rests her left side, in a graceful and reposing posture. On the pedestal a lyre of a classical form is held by her left hand, in an attitude that advantageously displays her elegant person; while her right, falling easily down the side, holds in its hand the instrument with which she has awakened that sprightly music which should ever accompany the Muse of the Dance. Reposing chiefly on the right foot, that side is slightly bent inwards, and the hip thrown out in an easy and graceful manner. Elegant sandals adorn, without concealing, her delicate feet. This graceful and symmetrical figure, thus pleasingly displayed, fills us, as we gaze on it, with

soft and harmonious sensations. A Grecian tunic of
fine and almost transparent texture, slightly veils the
beautiful forms of her bosom ; and the upper drapery,
descending from the left shoulder, encircles her waist
in the form of a wreath, and is gathered up in a knot
between her left side and the lyre on which she is
leaning. The turn of her head, and her look, express
all that gentle ecstasy in which the mind is held, when
under the enchanting influence of music. An exact
and elegant arrangement of the hair is given with pro-
priety to this muse, whose idea is ever connected with
our most refined and captivating sensations. Her tresses
are bound by a fillet of unusual form, but producing
an agreeable effect; and the fair, who would give
every advantage to their native beauty, cannot do
better than follow the models of such an artist.

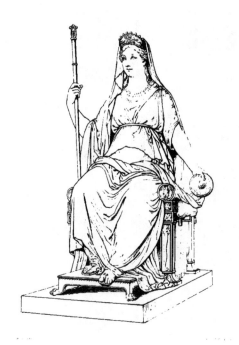

THE GODDESS CONCORDIA

THE GODDESS CONCORDIA.

CANOVA has here represented the Goddess Concordia
in the likeness of the Empress Maria Louisa; and the
felicity of the thought will be acknowledged, when
we carry back our recollection to the epoch when
this magnificent statue was imagined and executed.

The Goddess is seated on a richly ornamented
throne, her feet resting on a foot-stool; majesti-
cally attired in a rich tunic, whose ample folds
are skilfully disposed, and cover her whole person.
A flowing drapery descends from her crowned head,
in the most natural folds, down her shoulders; and
her well formed neck is adorned by a splendid chain
of jewels.

This august Goddess holds the sceptre in her right
hand, and in the other, the sacred patera. What
dignity and gentleness in that countenance! what
benignity of aspect! what an air of divinity in her
whole person! The beholder might almost believe
her, having taken the gracious likeness of Maria
Louisa, to be that same Goddess Concordia to whom
honors were paid in Olympia; and think, if such

prodigies had not been made familiar to us by the chisel of Canova, those happy times of Greece returned, when Juno and Minerva, seated on their splendid thrones, as Pausanias writes, received the homage of the citizens of Argos and of Tegea.

A narrow cincture gathers just below her swelling bosom, the ample folds of her tunic, the close sleeves of which, reaching to the elbow, are looped up in the Grecian costume.

This work, the production of which was one of the most difficult undertakings of our artist, is yet one of those in which he has been most successful; his genius seeming always to rise with, and to master the difficulties of his subject: and what subject can be more lofty than this one, both from its own exalted nature, and the dignity of the situation where it is placed?

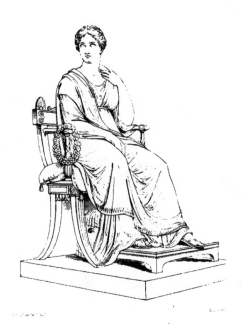

POLYMNIA.

POLYMNIA.

(A STATUE IN MARBLE.)

IT has been imagined by our great antiquary, Visconti, that Polymnia was the muse of Numa Pompilius, to whose inspiration he ascribed the wisdom of his laws, and to whom, as the goddess Tacita, he caused the Romans to pay divine honours. This silent and contemplative nymph the ancients supposed to preside over meditation, mysteries, and the mute eloquence of the mimic shews. Canova has felicitously represented her seated; a posture more than any other natural and proper, to one who meditates in solitude, on thoughts which memory awakens of the past; and, in doing this, he has not greatly departed from the ideas of the ancients, who have usually pourtrayed this muse with an air of tranquil meditation, and leaning with her elbow against a rock.

If it should be objected, in respect to the posture of this statue, that the ancients did not use to represent the Muses in a seated or reposing attitude, I might adduce the paintings of Herculaneum, in which Clio and Urania are seen seated, in a manner not greatly varying from this. The elegant chair in which

she reposes, is covered with a soft cushion, yielding
on all sides to the gentle pressure of her person; she
leans lightly against the back in an easy attitude, her
head being turned towards the left shoulder, with an
air expressive of tranquillity and deep thought. Her
majestic person is clothed in an elegant tunic, gathered
under the breast by a narrow band, and flowing down
to her feet in rich folds; over this a mantle of fine cloth
is gracefully disposed. Inclining somewhat to the left,
and resting slightly her elbow on the arm of the chair,
her hand is raised to the face, with an action that
finely expresses a state of meditation. When the
sculptor formed this pleasing and eloquent attitude,
he must have had in his mind the following epigram
from the Greek :—

" Taccio, ma parla in grazioso gesto,
" Mossa la mano, e taciturna in atto,
" Un loquace silenzio a tutti accenno."

The other hand, wrapped in the folds of her mantle,
rests on her lap; the hair is arranged with all the
care and elegance which become a muse, but is with-
out the wreath of roses, which, perhaps, the sculptor
deemed inappropriate to the pensive character of
Polymnia, but unwilling to be wholly without this
joyous symbol, he has hung on an arm of the chair a
chaplet of these flowers; beneath the chair is a large
scenick mask. The countenance, the hand and arm,

and beautiful feet of this nympth, the soft repose of her attitude, which, even while we gaze on her, infects us with its soothing influence; the drapery which falls around her in such rich and natural folds, all make us forget that it is a lifeless stone that is clothed with these soft and lovely forms.

Fitted by her character to raise lofty and contemplative thoughts, rather than those of a tender and amatory nature, this muse is the protectress of the philosopher, the legislator, and the artist, inspiring those high conceptions of ideal beauty and perfection, which tend so much to exalt and refine the human character.

Canova, this is thine own muse!

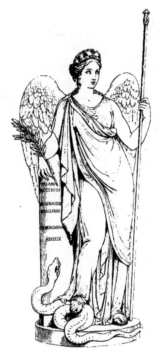

PEACE.

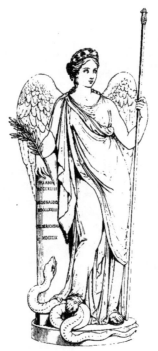

PEACE.

PEACE.

(A STATUE IN MARBLE.)

THE Grand Chancellor Romanzow had the glory of signing the treaty of peace by which Swedish Finland remained united to the Russian empire. His grandfather, and his father the Marshal Romanzow, had also each been distinguished by a similar event. This remarkable instance of the most grateful and honorable of all charges being bestowed by the confidence of their sovereign on three successive heads of the family of Romanzow, raised a wish in the count to obtain from the hand of Canova a statue of Peace—a divinity which seemed to be peculiarly connected with, and propitious to his race.

This amiable daughter of Themis and of Jove has been very variously portrayed by the ancients; a circumstance which left our Canova to the unfettered exercise of his own original genius. He has represented her in a standing posture, gracefully resting the elbow of her left arm on a short column, holding in her hand an olive branch, and pointing downwards to the inscription which enumerates the places and dates of the several treaties, and the names of those by whom

they were signed; her dress consists of a fine tunic, over which a mantle is elegantly disposed, sloping downward from the right shoulder to the opposite side. The artist has given large wings to her, to signify the rapid flight which is required of her by mortals, who are suffering the absence of her blessings; she holds a a sceptre in her hand, and her head is adorned with a regal diadem, befitting the dignity of a deity to whom all public and private happiness is owing.

A scaly serpent writhes beneath her foot, with which, without any appearance of anger or effort, she presses it to the earth. As the sentiments excited by this beneficent divinity are those of gratitude and veneration, rather than those of voluptuousness, the sculptor, with propriety, has modestly clothed her in ample drapery, which, however, does not wholly conceal the beauty of her form; the tranquillity and total absence of passion which belong to this benign being, greatly increase the difficulty of conceiving and portraying her placid features, which Canova alone, whose knowledge of expression is so profound, could have so finely and accurately imagined.

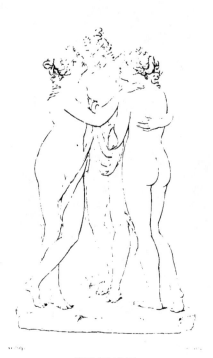

THE GRACES.

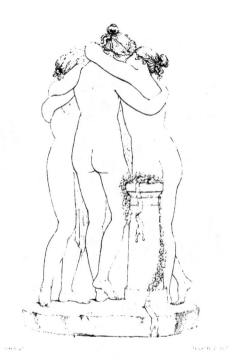

THE GRACES

THE GRACES.

(A GROUP IN MARBLE.)

THE Graces, Thalia, Aglaia, and Euphrosyne, are here represented by Canova, grouped in a manner which differs from that of the well-known figures which have been handed down to us from antiquity.

It would be wronging this enchanting composition to attempt a description of their elegant forms and attitudes, their beautiful arms, their countenances, and above all, of that tender and affectionate embrace in which they are joined. But in fulfilment of my undertaking, which has, however, no other object than to awaken in the minds of those who are yet unacquainted with the works of the unrivalled Canova, an encreased desire to behold them, I shall indulge in a few remarks on this attractive subject.

If ever the smiling Graces, these amiable daughters of Jove, lent their aid when invoked by our artist, and adorned his work, much more did they inspire him on this occasion, when he was employed in portraying themselves: these divinities had altars built to them by the wisest and most polished nations

of antiquity—divinities without whose favor no one
could hope for that bright and lasting fame to which
the best men aspire—divinities to whom Greece raised
innumerable temples and images, the works of those
consummate artists whose genius raise their country
to so great a height of glory.

It has been said by Racine, the most elegant of
the French poets, that grace is even superior to
beauty; to me, it seems, that grace is beauty sweetly
animated, or a sweet and gentle movement of beauty
itself, as it has been defined by the celebrated Lessing,
who felt deeply and justly in the fine arts, and settled
many of our sensations with appropriate terms. For,
indeed, I cannot imagine how grace can exist without
beauty, any more than beauty without grace; they
are then inseparable; although, when the former pre-
vails, our admiration is more directly excited; while
by the latter, our hearts are more unsuspectingly, but,
perhaps more surely enslaved. However this be,
the Graces were always invoked as divinities by the
nations of antiquity, although the mode of their
worship, their names, and even their numbers, suffered
change.

Josephine, whose name would have ever com-
manded our love and admiration, even if she had not
ascended a throne—Josephine, the model of every
amiable quality, who united in her favor the dis-

cordant nations of Europe; who, in the most exalted
station, was distinguished by the soft lustre of her
own gentle and benign virtues, more than by the
splendour of the great meteor which surrounded her.
This illustrious woman, whose fate drew tears from
the great Alexander, committed to Canova the task
of personifying these divinities, whose peculiar
favorite she was, and who attended her even to the
last moments of her eventful existence.

He has represented them naked, in the manner
of the best periods of the arts in Greece, with the
exception of a veil, which hangs from the arm of
Thalia, in the middle of the group, and floating play-
fully in the breeze, seems guided by the hand of
modesty herself. These lovely nymphs are linked
together in mutual embraces, their countenances
gently animated by the lightness and joyousness of
their hearts; how delightful to gaze on their finely
rounded arms, clinging tenderly round their sprightly
glowing bodies! and their delicate hands,

"Ove né vene appar, né nodo eccede"

resting here on a shoulder, here on a finely moulded
back, and in particular, on that one thrown ca-
ressingly round the neck, and reaching the cheek of
her lovely sister!

This composition finely personifies that abstract
idea of grace which prevailed among the Greeks, by

whom these deities were held in the highest venera-
tion; for to their inspiration was attributed all
that is gentle, beneficent, and noble, in the human
character.

The sculptor has supported this group by means
of an altar, which he has placed behind it; this,
however, would have been insufficient without the
wreaths of flowers with which it is crowned, and
which, though apparently too slight, serve admirably
the purpose of support: happy thought, to sustain
the figures of the Graces with flowers; and here, as
in the whole group, the genius of Phidias is blended
with the voluptuous spirit of Anacreon.

If, O Canova! following the example of the
great sculptors of Greece, thou shouldst raise thy
own statue, which all desire, and place it beside
some divinity, as it was their custom, let it be near
the Graces, with whom thou hast ever been so closely
united; for if in portraying their charms, thou hast
gained immortal honour, they also, sculptured by
thee, appear more beautiful.

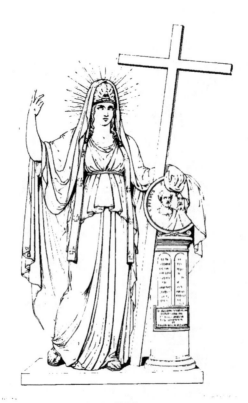

RELIGION

T

RELIGION.

(A STATUE IN MARBLE.)

In the presence of this sublime personification of religion, our minds are impressed with the profoundest emotions of veneration and devotion; what majesty of aspect! what dignity of attitude! what celestial tranquillity! The stature of this figure, which is about thirty palms, is encreased in appearance by the rays of glory which encircle the head, and are symbolical of the light of Christianity, whose benign rays diffuse their influence over the whole earth. On her head is the tiara, bearing in its front the symbol of the Trinity, in the centre of which the artist has placed an eye, significant of that all-seeing Providence, which unceasingly watches over all its works. This august figure points with her right hand towards heaven, as if in the act of announcing to mankind her sublime and eternal truths; while the left rests upon a medallion, on which the images of the apostles, Peter and Paul, are sculptured—those zealous evangelists who suffered martyrdom at Rome, during the persecution by Nero. On the left arm also is supported

the sacred standard of Christianity. A lock of hair falls gracefully down on each side of the neck, which is not entirely covered by the dress; an ample sacerdotal tunic, disposed in rich folds, clothes her whole person, beneath which her feet, dressed in sandals, are partly seen; the large plaits of her tunic are gathered beneath the breast by a cincture, revealing imperfectly her fine and majestic form. A scarf, ornamented with crosses, the emblem of the priesthood, falls down from the shoulders on each side; and a splendid mantle covering the head, flows down behind in majestic folds, adding greatly to the dignity of her figure. This fine statue is destined for that superb temple which is now being raised at Possagno, a place made illustrious by the birth of Canova, and the object of his warmest wishes; placed there, it will attest to all posterity, both the piety of his sentiments and the sublimity of his genius.

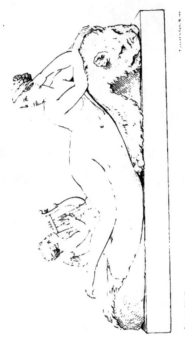

A NYMPH.

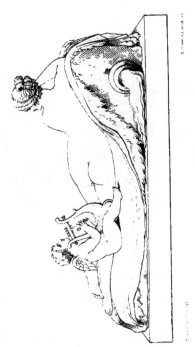

A NYMPH.

Plate 2

A NYMPH.

(A STATUE IN MARBLE.)

————

THIS Nymph, that now enlivens the cloudy atmosphere
of England, is reclining on a rustic couch, in an atti-
tude which differs slightly from that of the Venus Vic-
torious. She awakens at the sound of a lyre, the
chords of which are touched by a little Cupid, who is
seated at the lower end of the couch at her feet: his
boyish face is raised, and his eyes cast towards heaven,
as if in ecstasy at the harmony which proceeds from
his own lyre; on his little back, which is negligently
bent, are small wings, and his pretty face is adorned
with thickly curled ringlets. The Nymph, who was
sleeping with her face downwards, when awakened by
his melody, has raised her head to see whence it
proceeds, and leaning on the elbow of her left arm, the
hand of which supports her head, turns her face
towards the spot the better to observe and hearken to
the little lyrist; the other arm is stretched out on the
skin of a lion, which composes her bed, and together
with the elbow of the left arm rest on its frowning
head. Her graceful limbs are still in the listless atti-

tude of one who is not yet freed from the gentle domi-
nion of sleep, unlike the pliable features, which instan-
taneously reveal the sentiments of the mind ; her coun-
tenance, which is equally beautiful with her elegant
and perfect form, has the additional charm of sen-
timent, such as emanates from her pure and tranquil
mind. Her fine and delicate figure seems to partake
of the nature of ethereal beings, and to have been nou-
rished by purer food than earth produces. Although
naked, yet the soft voluptuous feelings which her
beauty inspires, are chastened by the gentleness and
modesty of her aspect.

If to the fine imagination of the poets, the praise
of creating these lovely ideal beings is due, and also of
enabling us, in some degree, to form an idea of them
by their pleasing descriptions, to our Canova is due the
greater praise of presenting to us, in a sensible form,
one of the most refined and admirable conceptions of
the human mind.

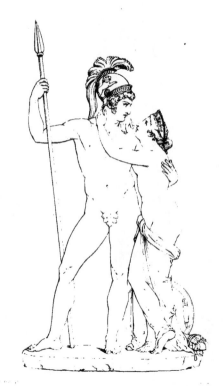

VENUS AND MARS

MARS AND VENUS.

(A GROUP IN MARBLE.)

In this charming composition the artist has imagined
and represented two of the most important deities of
mythology. They are here symbolical of war and
peace; and their noble figures, thus presented toge-
ther, form a fine contrast, and strikingly exhibit the
variety and extent of Canova's power.

This group presents an outline in some parts
bold and forceful—in others soft and flowing; and
possesses so entire a harmony and unity of effect, that
each figure would lose much of its eloquent expression
by being separated from the other. The warlike deity
prepares to follow whither destiny calls him; his forward
step, the homicidal spear which he grasps, and the
gleamy helmet, all indicate the approaching war. In
the posture in which he stands, the vigour and beauty
of his naked form—his ample chest and sinewy limbs
are fully displayed. The appeasing goddess leans fond-
lingly against his side, her right hand and rounded chin
gently pressing upon his shoulder, while her left hand
reaching round to his manly neck, caressingly draws

his regards towards her. Resting chiefly on the left foot, with the other thrown naturally and carelessly over it, her posture requires the supporting arm of Mars, which he, already half overcome, does not seem likely to withdraw; there is a captivating tenderness in her looks, but at the same time a searching glance, with which she seems to read in his eyes the progress of her victory. He, subdued by her caresses, looks fondly into her eyes, from which he seems to imbibe a pleasing and unusual calm. An elegant vest, in which she was clothed, has fallen neglectedly in rich folds over her lower limbs; her luxuriant tresses are knotted behind with careless elegance; and the diadem, her usual ornament, encircles her brows. How fine and just is the sentiment here, of beauty controlling those fierce and violent passions, which are tameable only by its resistless power.

AN INFANT ST JOHN

ST. JOHN THE BAPTIST.

(A STATUE IN MARBLE.)

———

CANOVA has here represented St. John, the precursor of Christ, in the state of childhood, apparently in about the fifth year of his age; he is seated on a block of stone covered with a fleece, and holding by both hands a cross which his prophetic spirit contemplates with an aspect of affection and sad foreboding; a narrow band wound round the cross has the inscription—ECCE AGNUS DEI.

The simple nature of the subject affording no scope for the employment of the embellishments of art, the sculptor has confined himself to the expression of the pure and artless beauties which are proper to the age of childhood. We particularly admire the execution of his soft and fleshy limbs, which seem warmed and animated with the vital fluid, and the double which is formed in his body, by the curved posture in which he sits, has all the softness and pliancy of nature. While we contemplate this pleasing figure, we forget that it is a work of art, and feel as if we were approaching to caress a gentle and attractive child.

WASHINGTON.

WASHINGTON.

(A STATUE IN MARBLE.)

IN this fine composition Canova has not only main-
tained the dignity of his subject, but (warmed by
admiration of the amiable qualities of this illustrious
man) has also infused into this statue an expression of
the gentleness and benevolence which attempered his
severer virtues.

The hero is sitting with an air of noble simplicity
on an elegant seat, raised on a double square base.
Nothing can surpass the dignity of the attitude or the
living air of meditation which it breathes; and the
grandeur of the stile, the force and freedom of the
execution, the close and animated resemblance to the
original, all conspire to place this statue in the highest
rank of art. The fine tunic which he wears is seen
only at the knee, being covered by an ample orna-
mented cuirass; above which is a magnificent mantle
fastened by a clasp on the right shoulder, and flowing
down behind in majestic folds. Beneath his right
foot, which is extended forward, is a parazonium
sheathed, and a sceptre, signifying that the successful
termination of the war, and the establishment of the
laws had rendered them now useless.

The hero is in the act of writing on a tablet held in his left hand, and resting on the thigh, which is slightly raised for its support. From the following words already inscribed on it, we learn the subject which occupies his mind—" *George Washington to the people of the United States—Friends and Fellow-citizens.*" In his right hand he holds the pen with a suspended air, as if anxiously meditating on the laws fitted to promote the happiness of his countrymen ; a border of the mantle, raised to the tablet by the hand which supports it, gives a fine effect to this graceful and decorous action. In his noble countenance the sculptor has finely pourtrayed all his great and amiable qualities, inspiring the beholder with mingled sensations of affection and veneration. This statue is only in a slight degree larger than the life ; his robust form corresponding with his active and vigorous mind.

If to this great man a worthy cause was not wanting, or the means of acquiring the truest and most lasting glory, neither has he been less fortunate after death, when by the genius of so sublime an artist, he appears again among his admiring countrymen in this dear and venerable form ; not as a soldier, though not inferior to the greatest generals, but in his loftier and more benevolent character of the virtuous citizen and enlightened law-giver.

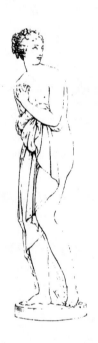

VENUS

VENUS.

(A STATUE IN MARBLE.)

THIS Venus is only slightly varied from the one which I have already noticed in a former number, and which was hardly allowed to be inferior to the Grecian goddess that exercises so propitious an influence on the destinies of Tuscany. The statue now under our notice was, however, sculptured many years later, and is distinguished by purity of design, and the most perfect and finished execution. The goddess has just come out of the bath, and is about to dry her limbs with a linen cloth which she holds in her hand; her body is modestly bent forward in a graceful curve, and her head turned towards the left shoulder, not as in the other statue, with the quick and animated glance of one who hears the approach of a beloved object, but rather with the retiring and tranquil expression of modest alarm. The shape of this Venus is more formed than that of the former, and there is more of ease and repose in her posture and features; the minutest difference which so consummate an artist has thought proper to make in two models of female beauty, executed at different periods of his life, is, doubtless, highly interest-

ing ; but I deem it prudent to desist here from a comparison which is dangerous even when between mortal beauties, and advise the lover of art to content himself, as I shall do, with tracing out and admiring the peculiar charms which each of them possess.

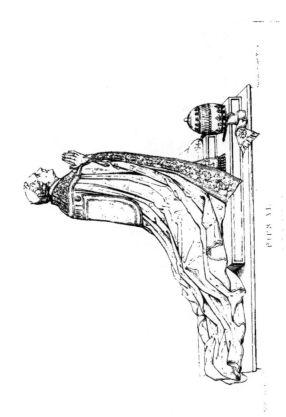

PIUS VI.

(A COLOSSAL STATUE IN MARBLE.)

———

CANOVA must have had in his mind, when he imagined this fine statue, that arduous moment in the life of Pius the Sixth, when he was torn from Rome notwithstanding his advanced age and infirmities, and forced to undergo the fatigue of crossing the Alps, during a season of unusual rigour, the hardships of which terminated his existence.

The aged Pontiff is seen kneeling on a cushion, placed on a raised ground, which is spread with a rich carpet; every part of his venerable figure is expressive of devotion: his hands joined together—his eyes raised towards heaven—his lips separated like one wholly absorbed in ardent prayer.

The sculptor has faithfully preserved the likeness of this Pope, and also, (with his admirable delicacy of touch) has given to the features an expression of that warmth of devotion and reliance on divine assistance which enabled him to maintain a firm and tranquil mind, amidst all the painful trials and dangers to which he was exposed. Beside him is placed the triple crown, and he wears on his head the solidio, a sort

of cap, whose name implies that its wearer does homage to God alone; he is clothed in a majestic sacerdotal robe, whose rich drapery extends far behind him, and suits with the dignity of his demeanour; the flower with which it is ornamented, belongs to the armorial bearings of the Braschi family.

While I was proceeding to state that this magnificent statue would be placed by the artist this very month of October, 1822, in the church of St. Peter's at Rome,* near to the steps that lead to the crypt, my pen was suddenly arrested by the sad intelligence that Canova had arrived at Venice, in a languid state of health; this rumour became on every succeeding day more alarming; and on the thirteenth we learned, to our infinite grief, that we had lost for ever this sublime genius, and most amiable of men.

* Canova in his last moments expressed great regret that he had not been able to make some slight alterations in this statue, which he had intended, and to place it in its destined site. But if ever those parts of this noble monument, which his severe judgment thought capable of improvement, should be observed, it will be more than recompensed by the interesting fact, that this statue was one of the last subjects of his exalted mind.

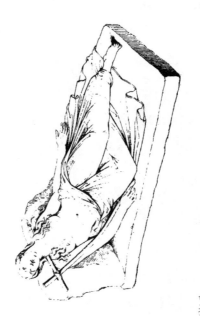

THE MAGDALEN

THE MAGDALEN.

(A STATUE IN MARBLE.)

THIS sublime image of the beautiful Hebrew penitent
awakens in us a deeply moral and religious feeling.
We see before us one, yet in the season of youth and
beauty, overwhelmed by the sense of guilt, and of
unworthiness of the divine compassion; living only to
devote herself to penitence and prayer. Kneeling, or
rather sunken abandonedly on the earth, wasted and
faint—her eyes fixed immoveably on the cross, this
impassioned figure conveys to us at once the ideas of
what she has been, what she now is, and what, ere
long, she will be; her early beauty is seen in the out-
lines of her fine countenance, and in the regularity and
harmony of feature which her pallid face still retains;
her streaming eyes and self-abandoned aspect shew
her present state, and the future seems indicated by
her sinking and death-like look—uncheered by that
divine ray with which a merciful God can illumine
the dark moments of approaching dissolution.